IMAGES
of America

MARYLAND'S
LIGHTHOUSES

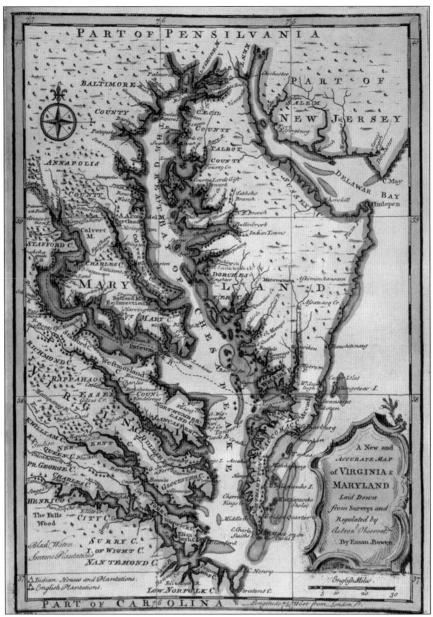

Maryland and Virginia have long shared the Chesapeake Bay, entering into an agreement that Virginia would allow ships free passage through to Maryland waters in order to reach its harbors. (Courtesy of the Maryland State Archives Special Collections [Huntingfield Corporation Map Collection of the Maryland State Archives] Emanuel Bowe, *A New and Accurate Map of Virginia and Maryland*, 1747 [1752]) MSA SC 1399–1–1.)

ON THE COVER. The Greenbury Point Light, on the northeast side of the Severn River, was built in 1848 and was captured in this photograph by Maj. Jared A. Smith in 1885. Had Greenbury Point Light been constructed 60 years earlier, perhaps George Washington's stormy evening trip on March 24, 1791, during his tour of southern states, would not have ended running aground here, just shy of his Annapolis destination. (Coast Guard Historian's Office [USCG].)

IMAGES
of America

MARYLAND'S LIGHTHOUSES

Cathy Taylor

ARCADIA
PUBLISHING

Published by Arcadia Publishing
Charleston, South Carolina

Printed in the United States of America

Library of Congress Catalog Card Number: 2007941490

For all general information contact Arcadia Publishing at:
Telephone 843-853-2070
Fax 843-853-0044
E-mail sales@arcadiapublishing.com
For customer service and orders:
Toll-Free 1-888-313-2665

Visit us on the Internet at www.arcadiapublishing.com

This book is dedicated to lighthouse admirers and volunteers, particularly in the Chesapeake Bay area. So many individuals have put their heart, soul, and sweat into helping preserve these beacons and their histories. I'd also like to dedicate this book to all the keepers and families who were devoted and bound to their posts. I've learned from experience that keeping a lighthouse, particularly one miles from shore and civilization, is physically demanding and exhausting work that requires strong, committed individuals.

Most of all, I'd like to dedicate this book to the members of Historical Place Preservation, for sticking through our early years and joining in the restoration of at least one Chesapeake lighthouse, and to my patient family (assistant keepers), who entertained themselves while I locked myself away to finish this book. I particularly enjoyed the carrot, celery, pickle, and cheese sandwich my son made for dinner so I wouldn't have to cook.

CONTENTS

ACKNOWLEDGMENTS

I am very much indebted to the Chesapeake Chapter of the U.S. Light House Society, particularly Henry Gonzalez and Anne Puppa, my mentors. I'd also like to thank Historical Place Preservation (HPP) board member Chris Overcash, for helping edit and perform last-minute scanning.

I would like to express my gratitude to other lighthouse preservation groups who put their research and transcripts of family interviews online, as I am a firm believer in the digital library, particularly when it comes to promoting and furthering interest in lighthouse stories and preservation.

Finally, I would like to thank Matt DiBiase at the National Archives in Philadelphia for the multitudes of lighthouse drawings ordered at various times, Chris Hayburn at the U.S. Coast Guard Historian's Office, Chris Kintzel at the Maryland State Archives, and Lauren Bobier, my editor at Arcadia.

Photograph credits from the Coast Guard Historian's Office are abbreviated to "USCG." Photographs without credits were taken by the author.

INTRODUCTION

The story of the rise and fall and potential rise again of Maryland's lighthouses encompasses less than two centuries of time—a short span when looking back at the recorded history of the state dating back to the earliest European settlers landing on St. Clements Island in the Potomac River in 1634. Maryland didn't receive its first permanent aid to navigation until over a quarter century after its neighbor to the south, Virginia, despite both states sharing the Chesapeake Bay. Once the first lighthouse, Bodkin Point, was built to mark the busy route into booming Baltimore in the early 1800s, the small state's rich history of light stations began and blossomed over the next century. Evidence of the different eras of lighthouse administration and technological advancements in providing an organized system of navigational aids is found in the varying architectural styles used as the 20th century approached and in the rapid decline of maintained light stations through the 1900s as technology overtook the need for keepers. Such advancements ultimately obliterated many of the picturesque lighthouses that liberally dotted the bay and rivers during the mid-1800s and into the 1900s.

From the early Colonial days, when agriculture, oystering, and fishing made up the bulk of local trade and shipping, to the population boom of Baltimore and Annapolis and rise of the iron and steel industries, Maryland's economy relied on the commercial centers that sprung up along its shores and the ability of vessels traveling in unfamiliar and occasionally unfriendly waters to reach ports safely. Conditions on the Chesapeake could change instantly, transforming calm flat seas into ocean-like, churning swells during gales, tossing boats over and leaving mariners blind to landmarks. Lightships proved unreliable, as they often were not marked with distinguishing features or colors and often broke loose from their moorings in exposed locations.

The stories of Maryland's lighthouses do not stand alone but rather weave and mesh together. Keepers often served at multiple lighthouses throughout their careers, leaving pieces of their families' histories strung throughout the beacons. When new light stations first shone, older, less effective lighthouses blinked out for the last time. Systems of using lights together in ranges for navigational purposes tied many lighthouses into inseparable pairs that stood together and fell together when no longer necessary.

Prominent figures in lighthouse construction forever tied to the history of Maryland's early attempts to light its dangerous shoals and river entrances included the fifth auditor of the treasury, Stephen Pleasonton, under whom all lighthouse administration fell beginning in 1820. Known to be extremely tight with the funds of the young government, he often cut corners during construction and implementation of lighting apparatus and didn't appear to have a clear plan of maintaining longevity of the aids constructed under his administration. John Donahoo, a native of Havre de Grace, emerged as the premier builder and knew how to work Pleasonton's bid system to earn construction contracts. Luckily, Donahoo's quality of work exceeded the price paid, and many of his stone towers still stand in places where they were constructed, away from the constant erosion of the bay. Despite warnings of encroaching waters at other locations, Pleasonton often built anyway if he could obtain the land inexpensively. Winslow Lewis emerged as a constant

figure in the early years, providing his lighting apparatus to all American lighthouses, despite advancements in technology used in Europe, such as the Fresnel lens.

While Pleasonton is often portrayed as incompetent and penny-pinching, and responsible for delaying the advancement and creation of an integrated system of aids to navigation, he wasn't entirely bad. He often demonstrated concern for families of keepers who died in service, appointing the surviving wife to the post to ensure the family wasn't left destitute. He also improved living conditions for families by upgrading kitchen stoves and adding porches to dwellings despite the additional expense of such comforts.

Pleasonton was ultimately relieved of his lighthouse responsibilities after a congressional investigation delivered a scathing report chastising his administration. The Lighthouse Board formed from the investigating committee in 1852 set about making sweeping improvements, such as replacing the Lewis lighting apparatus with the brighter, more efficient Fresnel lens across the country. The board sought opportunities to use new technology in creating the most efficient and effective system of aids to guarantee the safety of mariners, and the screwpile era of offshore lighthouses began in earnest in Maryland's waters.

Technological advancements that improved the system of navigation in the bay eventually spelled the demise of the classic lighthouse structures enthusiasts have grown to love. Fog bells learned to turn on automatically in soupy weather. Lights no longer required wick trimming or stores of oil, but could illuminate with the flick of a switch. Radio beacons and eventually GPS allowed for electronic means of navigation. No Maryland lighthouses were constructed during the tenure of the Bureau of Lighthouses, which took over the Lighthouse Board's role in 1910. The Coast Guard ultimately assumed responsibility for administration and maintenance of beacons in 1939 and discovered that placing automatic beacons on posts was much more cost-efficient than continuing with manned operations. A sweeping program of automation and dismantling of dwellings reduced many Maryland lighthouses to plastic beacons set upon the spindly legs of foundations that once supported picturesque cottages. Dwellings not dismantled were left decaying and exposed to vandalism.

With many heartbroken and horrified by the loss of such stoic and tangible pieces of the country's maritime heritage, foundations sprang up to try to save lighthouses and transfer them into museum settings. This often proved difficult in cases where the lighthouse still served as an active aid to navigation until the National Park Service implemented the National Historic Lighthouse Preservation Act of 2000. Under the new program, nonprofit and government organizations can apply for ownership of lighthouse structures in the program to restore, maintain, and preserve them for public use, while the Coast Guard retains jurisdiction of the navigational equipment inside. In cases where no acceptable organizations apply, the structures are sold at auction to private parties. Still in its early stages, this program could be the solution that will finally stem the tide of loss.

Finding the most effective way to organize such interwoven pieces of history proved an exciting challenge. Each chapter of this book focuses on a geographic area or destination port in Maryland's waters and shows chronologically how the lighthouses were erected to serve the needs of mariners in each region.

One

MARYLAND LIGHTHOUSE ARCHITECTURAL STYLES

Architectural engineering among Maryland's lighthouses varied greatly over the years of major construction, from 1822 to 1910, and was often determined by the time period and conditions of the proposed ground beneath the structure. Trial and error ruled many of the early construction attempts before the Lighthouse Board was officially established in 1852. The board quickly set out to create an organized system of placing and constructing aids to navigation in the Chesapeake using modern technology and techniques already employed by European countries.

Early land-based light stations were often stand-alone, conical stone towers accompanied by a stone keeper's dwelling set near the light tower (and in some cases, blocks away depending on land purchase issues). Often designs for the stone tower and dwelling were changed to incorporate a light tower upon the rooftop of a stone, brick, or wooden dwelling to save money. John Donahoo built most lighthouses of these styles.

The Chesapeake Bay is a constantly shifting and changing beast, easily influenced by storms. Erosion and dangerous shoals necessitated the location of lights nearer to the water-based hazards than land-based lights could serve. Initially, a few light ships filled that role, but eventually they were phased out and the picturesque screwpile design with wooden superstructures, or dwellings, mounted atop became the popular choice.

Screwpile construction seemed to work well with the soft bottoms of the Chesapeake, although setting the piles straight often proved challenging. After these wooden dwellings repeatedly became mortal victims of brutal winter ice, the more expensive but sturdier caisson cylinder bases for lighthouses were employed. Setting these large caissons in the shifty and soft bottomlands of the bay often involved drama.

Only four screwpile foundation lighthouses remain, and only one of those, Thomas Point Shoal Light Station, still sits where it was erected. All of the heftier, cement-filled caisson light stations still stand on their original sites, although a couple are a little worse for wear.

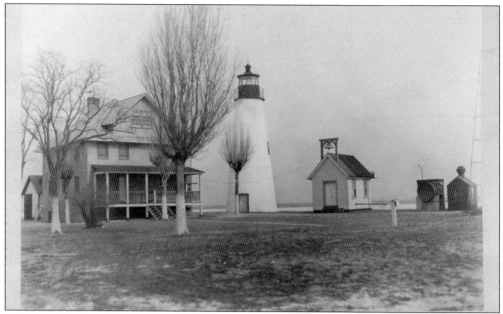

The first architectural design employed in Maryland consisted of a conical stone or masonry tower with detached dwelling, as demonstrated by Cove Point in this photograph taken in 1928 by W. J. Taylor. Most sites also included a bell tower, generally constructed of wood, and outbuildings for oil storage and animals. Families often lived with the keeper in the dwelling and helped with daily chores. (USCG.)

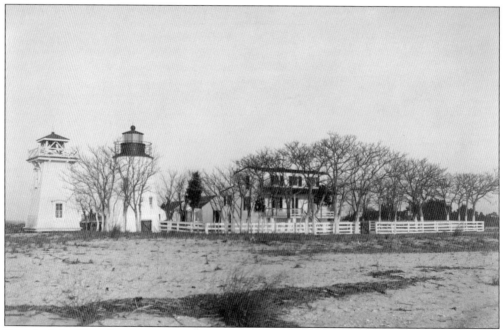

Detached dwellings for stone towers often started as single story and were later expanded. Fog bell towers came in varying sizes, shapes, and material with a mind toward how the sound carried. Piney Point, on the north side of the Potomac River, was built in 1836 and was expanded from one story to two in 1884 with a porch added, as shown in this 1912 photograph. (USCG.)

Cost-cutting was foremost on the mind of the man overseeing construction of Maryland's lighthouses, the fifth auditor of the treasury, Stephen Pleasonton. Oftentimes, costs associated with land acquisition left less money available for the light itself. In such cases, a dwelling with lantern mounted atop the roof, such as Point Lookout, built in 1830 and seen in this 1883 photograph by Major Jared A Smith, saved expenses. (National Archives.)

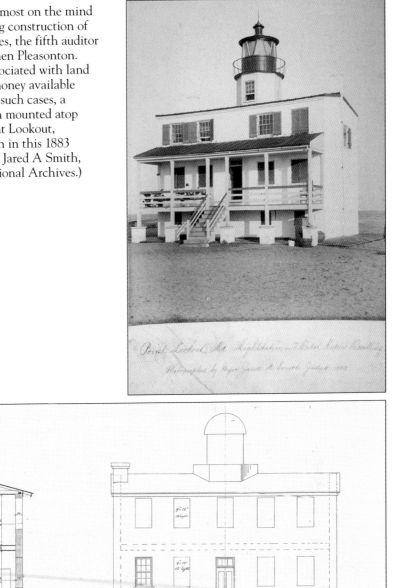

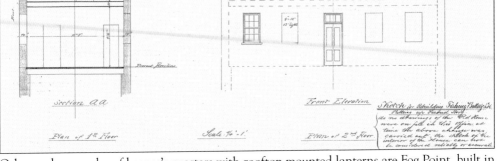

Other such examples of keeper's quarters with rooftop mounted lanterns are Fog Point, built in 1827, and Clay Island, built in 1832. Both of those lighthouses succumbed to erosion and were lost apparently before photographs were taken. Point Lookout and Fishing Battery (1853), both built by John Donahoo, are the only two still standing. This sketch shows Fishing Battery after the second-story addition. (National Archives.)

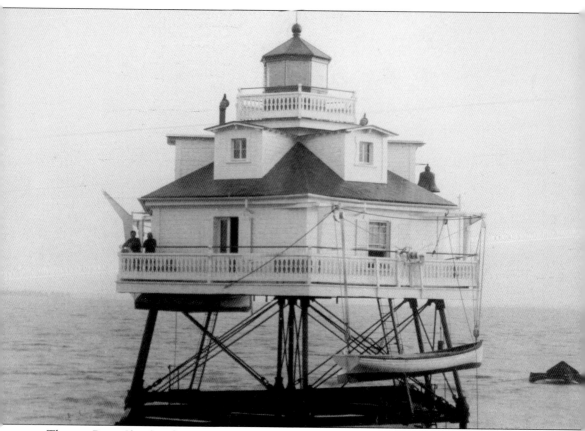

Thomas Point Shoal Light Station, the most recognizable and photographed lighthouse on the Chesapeake Bay, is a perfect example of the once highly common screwpile, wooden, hexagonal, cottage-style lighthouse. Typically, the foundation was secured at the proposed lighthouse site and the prefabricated superstructure then was towed and assembled on top. Variations on the screwpile superstructure included square, wooden cottages, one round iron dwelling, and variations in the number of levels between the foundation and lantern. These structures turned out to be highly susceptible to deadly winter ice. Many were rebuilt a couple of times or eventually were replaced. Screwpile lighthouses not lost forever to ice or fire were dismantled during the age of automation, leaving only 4 of the nearly 20 Maryland cottages left in existence. (USCG.)

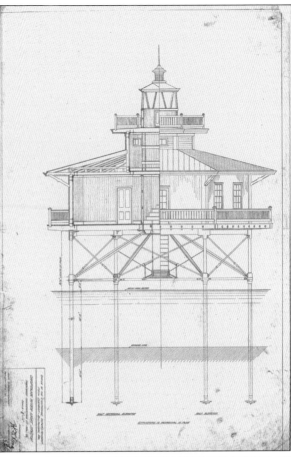

The lighthouses were named screwpiles because of the method of literally screwing the typically wrought iron foundation rods into the soft mud of the bay to anchor the structure atop the foundation. On occasion, another method was employed using sleeve-piles. Wooden piles were driven deep and then encased in less expensive cast iron sleeves to protect them. To combat flowing ice, engineers dumped riprap, or loosely piled chunks of stone, to attempt to create artificial "islands" as a method of stopping ice from building up around the foundation and pushing the structure over. These images show Choptank River Light Station foundation plans. (National Archives.)

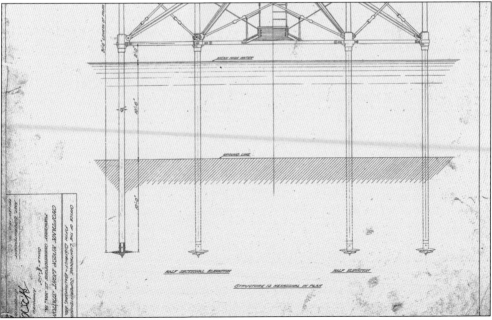

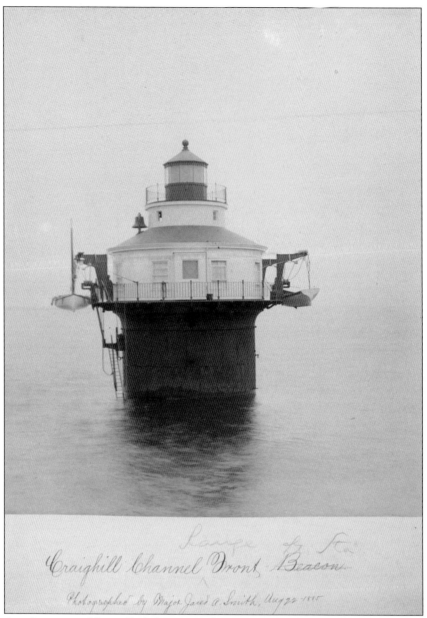

Craighill Channel Front Beacon

Photographed by Major Jared A. Smith, Aug 22 1885

To combat the repeated loss of lighthouses to flowing ice, the Lighthouse Board decided to try the sturdier caisson sunken cylinder design in the early 1870s in the hopes it would withstand ice better. Over time, many screwpiles were replaced with caissons. While the financial benefits over the long run outweighed the initial cost and difficulties of towing the caissons to their sites and setting them in the bottomlands, many disasters ensued during construction of these hardy lights. Conditions of the bay bottom usually caught engineers by surprise, and planned methods for sinking caissons required reengineering if the prebuilt caisson itself wasn't lost first. Calm weather conditions were vital for the successful setting of the caisson into the bottom of the Chesapeake, and it took a special bunch of workers to dig and set the caissons while risking their lives should anything go wrong. Maj. Jared A. Smith photographed the first caisson in the Chesapeake, Craighill Channel Lower Range Front Light Station, on August 22, 1885. (USCG.)

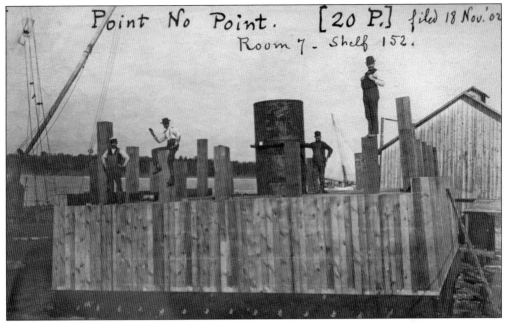

Point No Point used a 32-foot-square by 13-foot-high wood caisson with bottom working chamber and an airshaft run into it. The airtight working chamber occupied the bottom of the caisson, and rounded iron plates were attached to the exterior. Workers dug from this chamber as the caisson was sunk deeper into the bay's bottom. Earlier caissons were sunk using their own weight. (National Archives.)

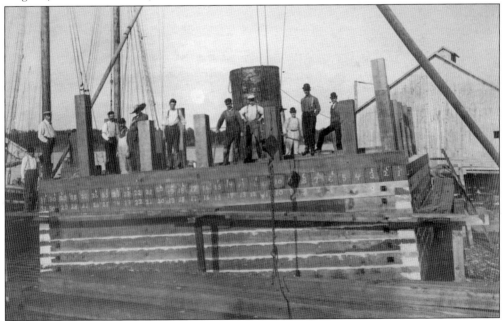

Workers who dug below the earth's surface were termed "sandhogs" and were most notoriously associated with the Brooklyn Bridge laborers who sunk the caisson supports. Due to the dangers and health risk involved in such work, it took a special type of man to sign on for this job. (National Archives.)

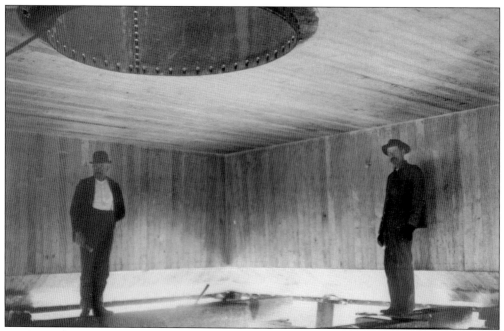

Workers entered the airtight working chamber through a special shaft and air lock. Air was then pressurized to keep water from getting in while the workers dug the bottoms out, and the cutting edge of the caisson sunk deeper. Transferring men out of the working chamber required special care while men passed back through the airlock and the surrounding pressure was slowly decompressed. (National Archives.)

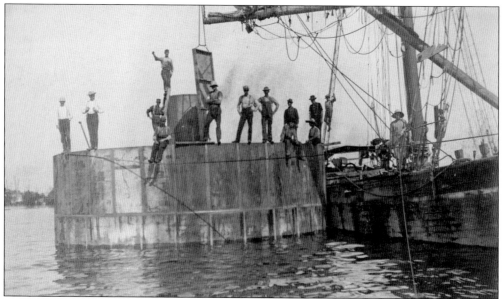

Using an airtight working chamber and pumping water and smaller materials out allowed workers to dig and was known as the pneumatic process. Hooper Island employed the pneumatic process of pumping material from the caisson's cutting edge while concrete and stone were poured into the structure above to help weigh it down. The working chamber was filled with concrete once the structure reached the proper level. (National Archives.)

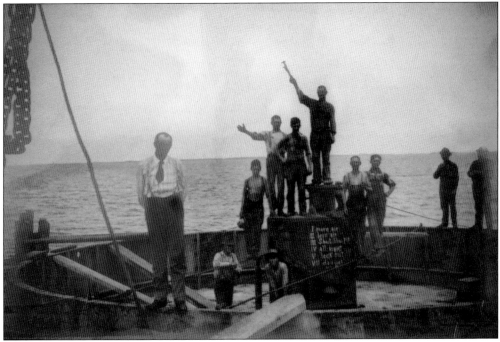

A frequent occupational hazard for sandhogs caused by returning too quickly from the pressurized working chamber to normal atmosphere was being stricken with decompression sickness, also termed "caisson sickness." The air shaft in this photograph has what appear to be signals painted on it: "I more air, II less air; III Shut blow pipe; IV all right; V lock out, VII danger." What happened to VI? Often the eyes, nose, and ears of workers would begin bleeding inside the chamber. Sandhogs also faced the danger of hitting lethal gas pockets concealed under the earth they dug in. (National Archives.)

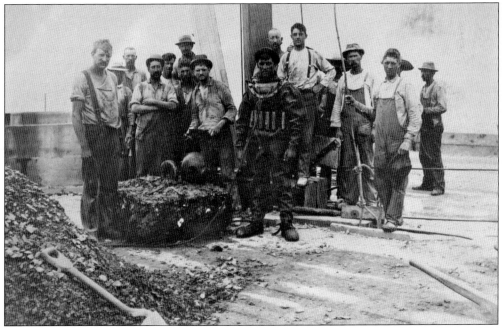

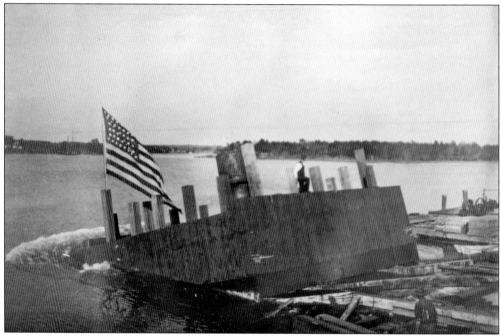

Most early construction for caissons took place at a lighthouse depot, and once the working chamber was completed and a few courses of iron attached, the awkward caisson was floated and towed to the site for the lighthouse. Generally, as the caisson was sunk deeper, further courses of iron were attached to the sides and continued up. These images of the Point No Point caisson demonstrate the awkwardness of towing the early lighthouse foundation. Most mishaps during caisson construction occurred during this phase when gales arose while under way or from tipping over after reaching the proposed site. (National Archives.)

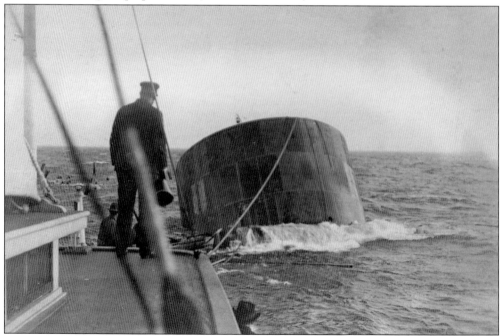

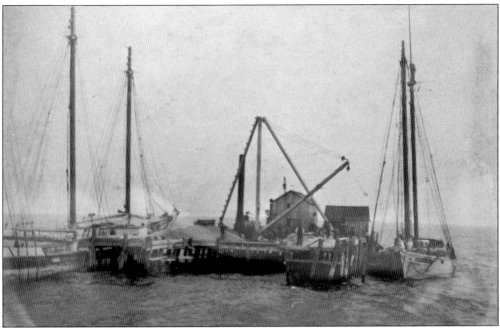

Iron was known to resist corrosion from salt water and became the main choice for construction of caisson-style lighthouses. Temporary piers and housing were constructed at the lighthouse site, and the partially finished caisson mounted to the piers before it was sunk into position to keep it from tipping. In cases where caissons did tilt out of position, gravel and sand often had to be poured into the higher side to balance the foundation out and get it to sit right. In some cases, the caisson required towing back to shore, adding more courses of iron or ballasting, and returning to the construction site. (National Archives.)

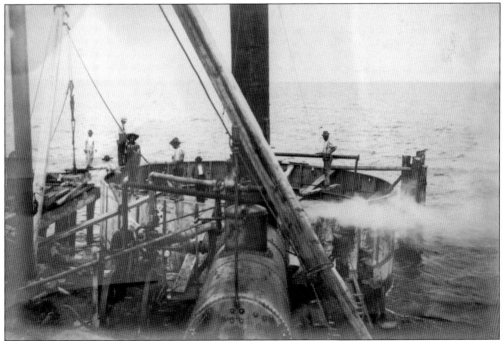

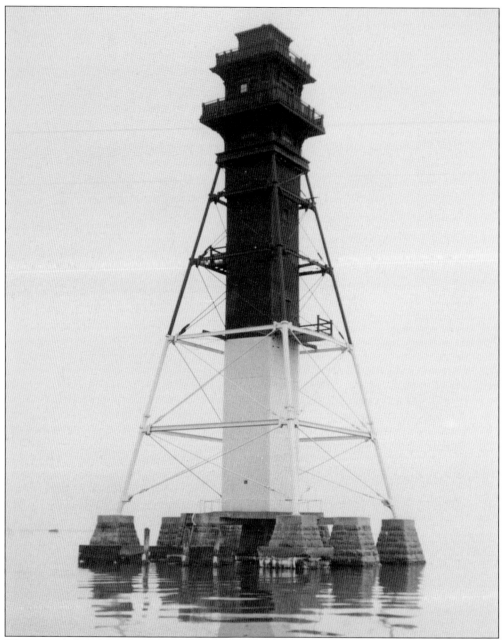

There are only two skeletal tower lighthouses marking Maryland's waters, and interestingly enough, both are part of the two pairs of Craighill Channel Range lights. The first, the Craighill Channel Lower Range Rear Light, consists of an iron exoskeleton pyramidal framework encasing the tall tower. The rear light of the Craighill Channel Upper Range is also a tower inside skeletal framework. This photograph of the Craighill Channel Lower Range Rear Light, taken in the winter of 1959, clearly shows the skeletal framework. Both were constructed of wrought iron framework over corrugated metal sheathing the towers. (USCG.)

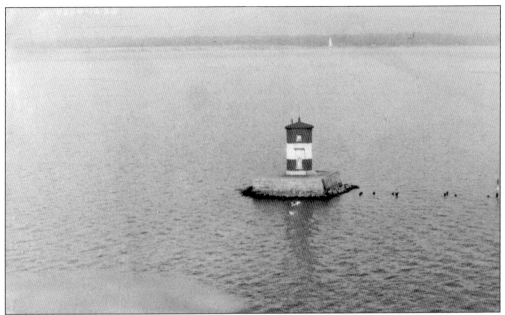

Range light pairs typically exhibit taller lights in the rear tower. Captains line the front and rear lights up vertically to remain on course in the channel. Once they drift off-course, the lights no longer align. The Craighill Channel Upper Range Rear Light is faintly seen in the distance of this photograph featuring the front light. (USCG.)

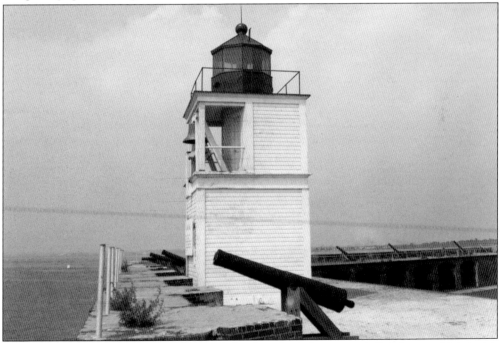

Less commonly constructed were the straight brick-and-wood, tower-style lighthouses. Mainly this type of wooden tower construction contained land-based fog bells to aid the carriage of sound. On occasion, these towers housed the navigational lights themselves. This photograph of Fort Carroll's wooden light tower was taken on August 15, 1960. (USCG.)

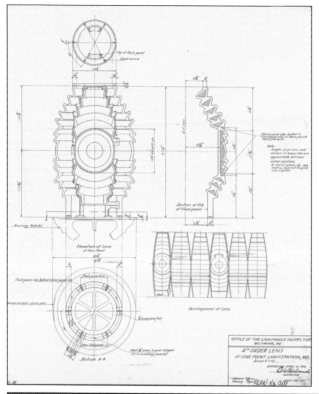

Once established in 1852, the Lighthouse Board made sweeping upgrades to the lighting apparatus on all Maryland lighthouses over the next several years. Old Argand-style lamps and parabolic reflectors of Winslow Lewis gave way to the modern and higher candlepower Fresnel lens invented in France. More efficient, lower fuel consumption over time offset the initial expense of refurbishing light stations, such as Cove Point, which received this fourth-order Fresnel lens, as shown in drawings from the National Archives in Philadelphia. Fannie Mae Salter, keeper of Turkey Point, cleans the glass prisms of the lens under her care, which continued in service after being lit by a single electric light bulb. (USCG.)

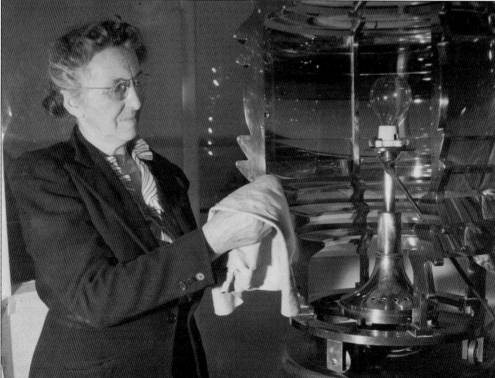

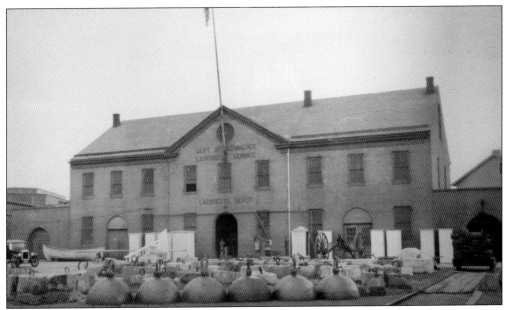

Over time, two lighthouse and buoy depots became important in Maryland. The first was at Lazaretto Point in Baltimore. Most Maryland screwpile lighthouse superstructures and shore-based fog bell towers were constructed at Lazaretto before being shipped to their construction sites. In addition to construction, Lazaretto Depot was primarily responsible for buoys and associated equipment in the upper bay as well as for repairs to lighthouse vessels. (National Archives.)

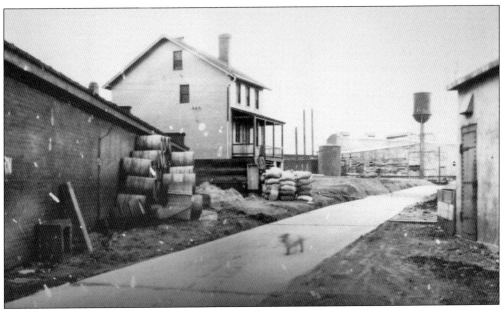

After requesting permission to use the vacant treasury building next door to the existing Lazaretto Point light tower, the unoccupied building became the office for the district in the 1860s. The depot grew into a bustling hub of activity from construction of caissons, carpentry work, buoy and coal storage, to a radio lab in the 1930s. (National Archives.)

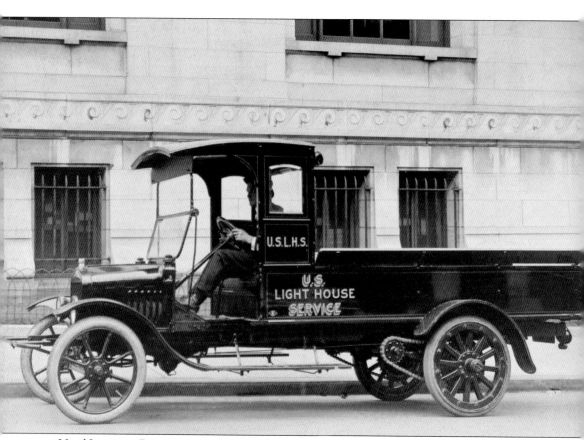

Until Lazaretto Point went into use as a depot, Portsmouth, Virginia, served as the primary depot for the entire Chesapeake Bay region. As the system of aids grew throughout the region, splitting up the responsibilities became necessary, particularly because of the great distance and time required to travel from Portsmouth to the upper reaches of the bay. The Lazaretto Depot took much of the buoy repair and replacement responsibility load off Portsmouth while also allowing necessary work to be completed faster. Eventually, another depot was added across from Annapolis in 1896 to take over buoys from Sandy Point south to the Patuxent River while Lazaretto Depot remained responsible for the northern portions of the bay. This U.S. Lighthouse Service Ford Form A auto truck from the Portsmouth Depot was photographed in Baltimore in 1916 by the Hughes Company. (National Archives.)

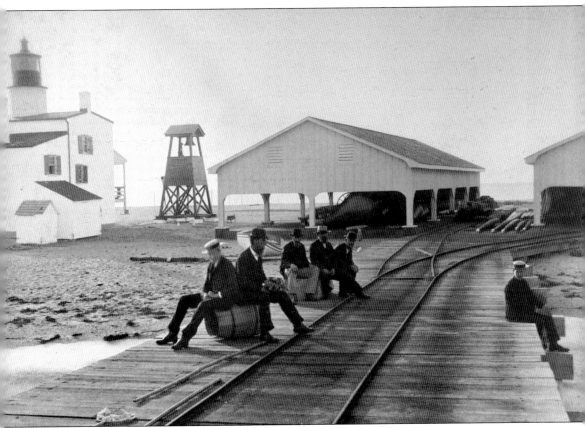

No longer serving as a hospital or prisoner of war camp, Point Lookout found a new purpose serving as a lighthouse depot. To cut the time required to travel the distance to Lazaretto Point or the Portsmouth Depot, a buoy shed and wharf were added to Point Lookout in 1883, and the house and lantern were raised to two full stories, moving the lantern from 24 feet to 41 feet above water. The relocated fog bell made room for the new buoy and coal sheds as the sound no longer carried following construction of the taller sheds. Maj. Jared A. Smith photographed the added tram rails, which eased moving heavy buoys between the tenders and the shed at Point Lookout on July 3, 1885, before a new wharf was built in 1890 that also widened the tramway. (National Archives.)

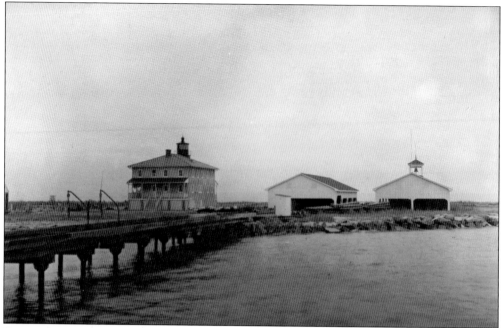

Depots served as warehouses for lighthouse provisions such as coal and lamp oil, replacement parts, and buoys. Point Lookout appears to only have been a warehouse for buoys and coal as a midway point between the Portsmouth Depot and the Lazaretto Point Depot, but did not host construction like the other two. (USCG.)

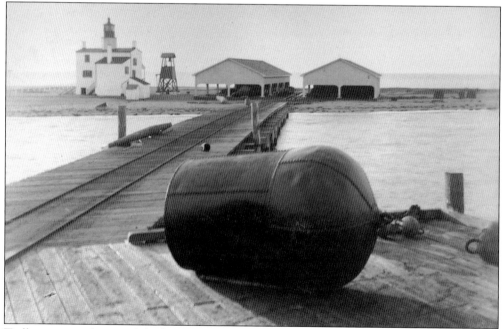

Trolley carts easily moved the buoys off the tenders and into the sheds using tram rails. Trams, such as the one shown at Point Lookout Depot, were common at lighthouse depots and buoy sheds. Later, the wharf was rebuilt and the tram was upgraded. Lazaretto Depot and Portsmouth were also fitted with trams. (USCG.)

Tenders often picked up and delivered buoys, taking them to the nearest depot for repairs or painting, and then returned them to their proper spot. During harsh winters, tenders spent much time visiting buoys to pick away at the ice built up on them. Tenders also carried construction crews to sites as well as supplies to off-shore light stations, of which there were many in the Chesapeake. Keepers' children looked forward to the arrival of tenders dropping off or picking up buoys, enjoying the opportunity to hang out with the ship's men and listen to their stories and experiences. Tenders were originally contracted out, but over time, the U.S. government built their own in order to better meet the unique needs of serving in the lighthouse service. Speed and efficiency of the vessels improved as the years progressed. (National Archives.)

Initially wooden buoys were covered in valuable copper, but later were manufactured using iron to save money and make them less attractive to thieves. Technological advancements allowed for the introduction of buoys topped by bells that rang from the motion of the waves. Such advancements augmented the development of an organized system of aids meant to make navigation safer and easier. (National Archives.)

Maryland's lighthouses composed a portion of the eventually organized Fifth District. The districts persist to this day under the Coast Guard, and Maryland lighthouses still fall under it. The Fifth District offices resided at the Lazaretto Depot until operations were gradually transferred from 1921 to 1938 to the Portsmouth Depot. (National Archives.)

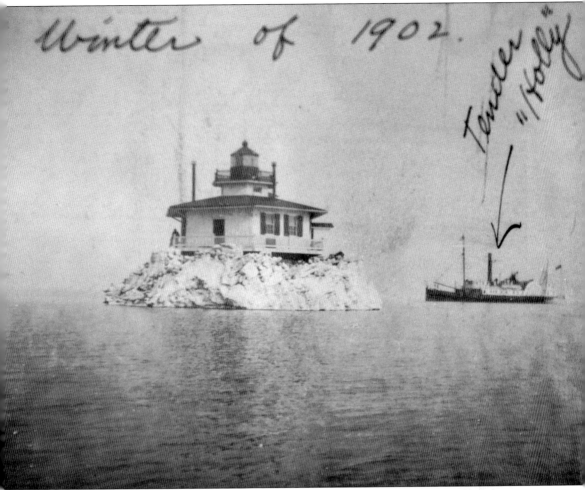

Winter of 1902.

Tender "Holly"

Tender *Holly*, one of the last steam-powered side-wheelers to tend to the system of lighthouses and buoys, frequented many of the light stations on the Chesapeake Bay, bringing supplies of coal and lamp provisions to lighthouse keepers during the 1881–1913 era. *Holly* had even temporarily served a lightship. She is shown approaching the ice-bound Love Point Light Station at the tip of Kent Island on the Eastern Shore. One of her many duties entailed carrying the district inspector to lighthouses, apparently so frequently that he had his own elegant stateroom on board. Pres. Grover Cleveland also partook of bay excursions on the vessel. *Holly* was an impressive vessel that served the lighthouses and keepers for more years than any other tender, and her profile is often seen in the backgrounds of historic photographs. (National Archives.)

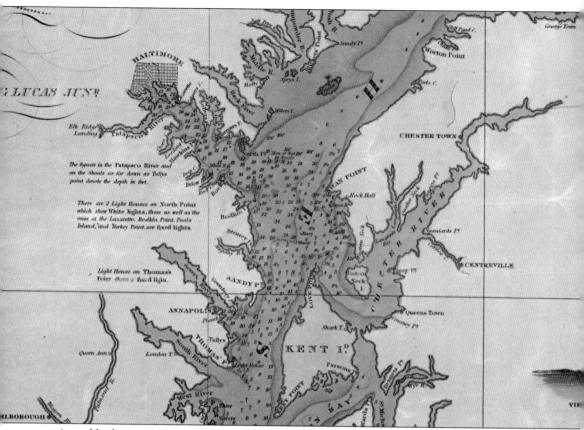

Arguably the most important harbor for commerce and trade because of its increased industrial activity and ranking as the third most populous city in the nation by 1820, Baltimore became the first destination to have permanent aids to navigation appropriated in the state of Maryland. Marking the turn from the Chesapeake up through the Patapsco River required more than buoys, particularly at night, and the first three lighthouses were commissioned on each side of the river's entrance at Bodkin Point on the southern side and North Point on the north side. This 1832 map shows some of the early lighthouses, many of which no longer exist. (Courtesy of the Maryland State Archives Special Collections [Huntingfield Corporation Map Collection of the Maryland State Archives] Fielding Lucas, Jr. "A Chart of the Chesapeake and Delaware Bays, 1832" MSA SC 1399–1–295.)

Two

LIGHTS TO BALTIMORE
THE EARLY YEARS

Since traveling on the water was easier than by land, early Maryland residents settled and formed towns mainly in protected harbors and along rivers. Fishing and oyster trades flourished along with tobacco's growth and distribution. Maneuvering narrow channels between shoals proved difficult for larger schooners with deep drafts, and a system of marking shipping routes into the port of Baltimore became necessary.

Maryland's lighthouses in chronological order with rebuilt dates following:

1822 Bodkin Point
1822 North Point Range
1825 Poole's Island
1825 Thomas Point, 1840, 1875
1827 Concord Point
1827 Fog Point
1828 Cove Point
1830 Point Lookout
1831 Lazaretto Point
1832 Clay Island
1833 Turkey Point
1836 Piney Point
1838 Sharps Island, 1866, 1882
1848 Greenbury Point
1851 Blakistone Island
1853 Fishing Battery
1854 Fort Carroll
1856 Seven Foot Knoll
1857 Fort Washington, 1882
1858 Sandy Point, 1883
1867 Hooper Strait, 1879
1867 Janes Island
1867 Lower Cedar Point

1867 Upper Cedar Point
1867 Somers Cove
1868 Leading Point
1868 Hawkins Point
1871 Choptank River, 1921
1872 Love Point
1873 Craighill Channel Lower Range
1875 Solomons Lump, 1895
1876 Mathias Point
1882 Bloody Point Bar
1883 Drum Point
1884 Great Shoals
1886 Craighill Channel Upper Range
1889 Cobb Point Bar
1889 Holland Island Bar
1891 Greenbury Point Shoal
1892 Maryland Point
1892 Sharkfin Shoal
1896 Cedar Point
1902 Hooper Island
1905 Point No Point
1908 Baltimore Harbor Light
1910 Ragged Point

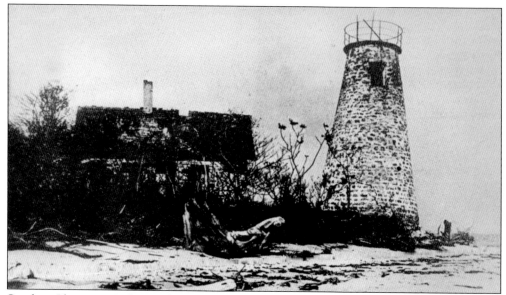

Stephen Pleasonton's first task in Maryland was marking the Patapsco River entrance to Baltimore, resulting in construction of this stone tower and dwelling on Bodkin Island in 1821. The light of this first Maryland lighthouse finally glowed in 1822. (Unknown photographer from the early 20th century of Old Bodkin Point Lighthouse, courtesy of the Maryland State Archives Special Collections [Maryland State Archives Collection of Donated Photographs] MSA SC 1887–1–32.)

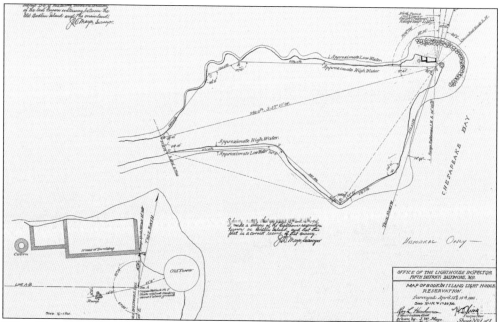

What Pleasonton lacked in leadership and innovation he made up for with frugality. Despite warnings about erosion or the fitness of contractors, Pleasonton nearly always accepted the lowest bid. This may explain why many of his lighthouses, including Bodkin Point Light and the entire Bodkin Island, no longer exist. The two North Point range lights built opposite on Sparrows Point in 1822 are also only a memory. (National Archives.)

Sailing and steamer traffic increased, yet Baltimore itself remained unlit until the Lazaretto Point lighthouse built by John Donahoo went into service in 1831, nearly a decade after the Bodkin Island and North Point Range lights. A conical tower, wooden fog bell, and keeper's dwelling occupied the site initially. A replica tower now stands there. (National Archives.)

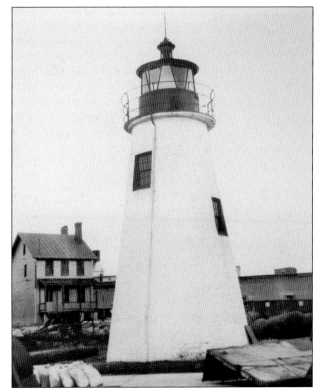

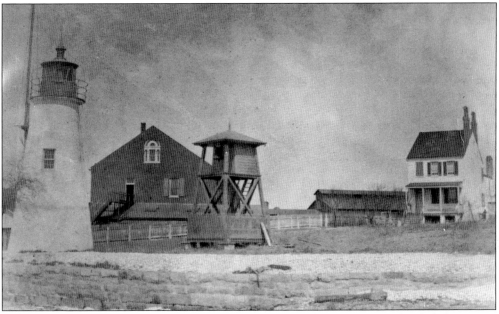

"Lazaretto" means contagious diseases, and the site where the Baltimore Harbor lighthouse was built formerly contained a hospital. In Pleasonton's desire to save money, he even requested the bricks from the hospital be reused for the keeper's dwelling. Expanding into an old treasury building on the site, Lazaretto Point became a major lighthouse depot and wharf, restocking tenders and hosting construction of new lighthouses beginning in 1863. (USCG.)

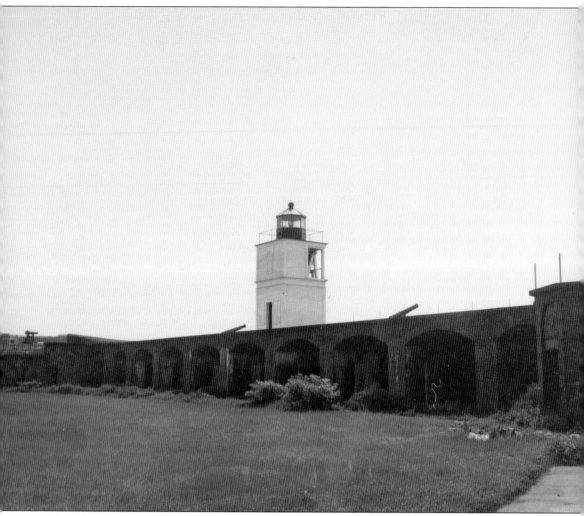

Many don't associate lighthouses with war, but early wars did impact lighthouses in different ways. During the war of 1812, lighthouses in Virginia were extinguished in the hopes that British ships would run aground while making their way through the unfamiliar Chesapeake Bay and up the Potomac to Washington, D.C. The idea had some positive results, as many ships were grounded. During the Civil War, lighthouses in the South suffered much damage during fighting, although Maryland's lighthouses were largely spared. The lightships, however, weren't as lucky. Radio communications were often tested at light stations in order to determine their best use during wars, and lighthouse keepers were often required to sit and monitor radio frequencies during times of war. Fort Carroll and the wooden lighthouse still exist in the middle of the Patapsco but in a serious state of neglect and deterioration. (USCG.)

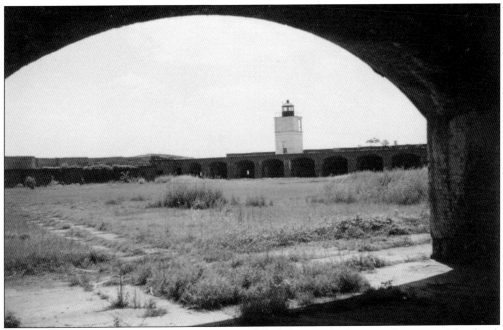

Originally painted brown, this 1854 wooden tower lighthouse, the first wooden one in Maryland, sat on a parapet of man-made Fort Carroll in the Patapsco River, just south of the Key Bridge. The fort was reconfigured several times during the course of the Civil War and World War I and II, yet was never really put into action or completely finished. (USCG.)

During those reconfigurations, the light tower itself was relocated several times on the fort over its lifetime. A keeper resided in a rectangular dwelling constructed on the fort as shown in these plans. No evidence of the dwelling exists on the privately owned weathered fortress ruins said to be rodent-infested. (National Archives.)

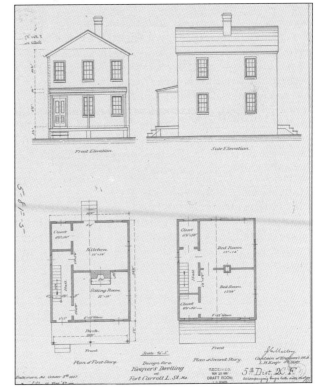

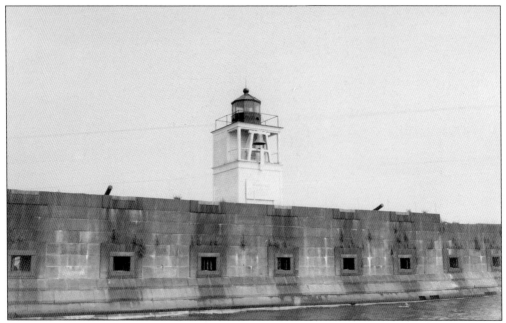

The Fort Carroll light marked the turning point for ships into or out of the Fort McHenry and Brewerton Channels. Never seeing live action, the fort was left abandoned with the light being the only remaining government purpose. A name named Benjamin Eisenberg purchased the fort in 1959 with a reservation that the light remain under the Coast Guard. When vandals forced the light out of service in 1964, Eisenberg claimed the Coast Guard was bound to repair and reactivate it, according to the reservation clause. He refused to allow the tower to be demolished and removed, yet he also left documents transferring ownership and liability to him unreturned. Surprisingly the tower has survived decades of being in limbo and still stands atop the fort ruins. (USCG.)

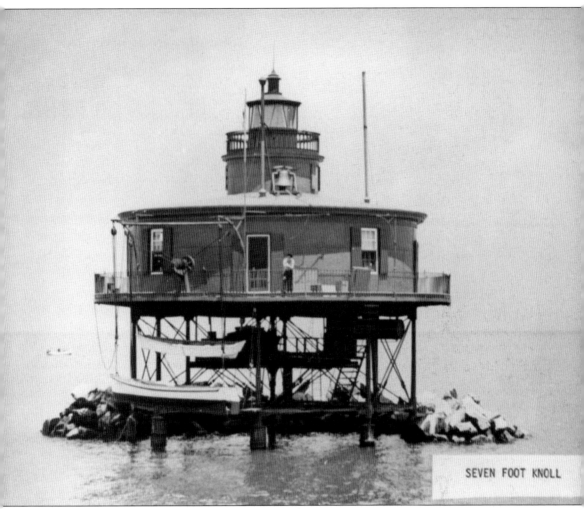

SEVEN FOOT KNOLL

The federal system of lighthouse effectiveness and maintenance under Pleasonton's reign came under fire by mariners, and a congressional committee was formed to investigate the system of aids to navigation. Their findings resulted in the ousting of Pleasonton and the formation of the Lighthouse Board in 1852. During this time, those with maritime interests in Baltimore called for a lightship to be placed at Seven Foot Knoll, claiming the original Bodkin Point and North Point Range lights were not effective at guiding ships into Baltimore. Since lighthouses had no distinguishing marks and utilized the poor illuminating apparatus of Winslow Lewis, foreign captains found locating the proper channel to Baltimore difficult. A new lighthouse planned for Seven Foot Knoll made the Bodkin Point lighthouse unnecessary, and it was decommissioned after completion of the new water-based lighthouse. The new Lighthouse Board took advantage of new technology and installed the brighter, more efficient Fresnel lens in the lantern of the structure. (USCG.)

Baltimore evolved as a major supplier of ironworks in the country. Original plans for Seven Foot Knoll called for a brick dwelling screwpile lighthouse based on the nation's first screwpile, Brandywine Shoal, in Delaware Bay, New Jersey. These were scrapped and a square local-industry iron dwelling topped Maryland's first screwpile and the nation's second in 1855 instead. This round iron dwelling with outhouse underneath eventually replaced the square one. (Library of Congress.)

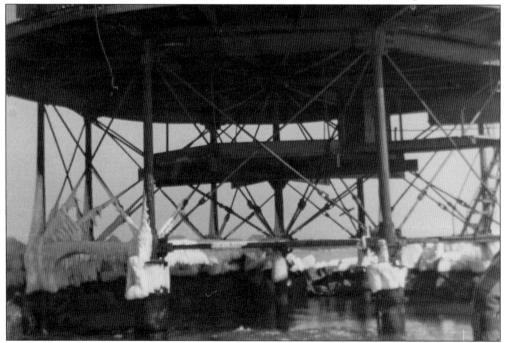

Screwpiles became notorious over the years for their susceptibility to ice damage and destruction. Having the distinction of being the first screwpile built in Maryland, Seven Foot Knoll weathered the test of ice ahead of others. The lighthouse no longer serves as an active aid to navigation but stands as part of the Baltimore Maritime Museum in Baltimore's Inner Harbor. (USCG.)

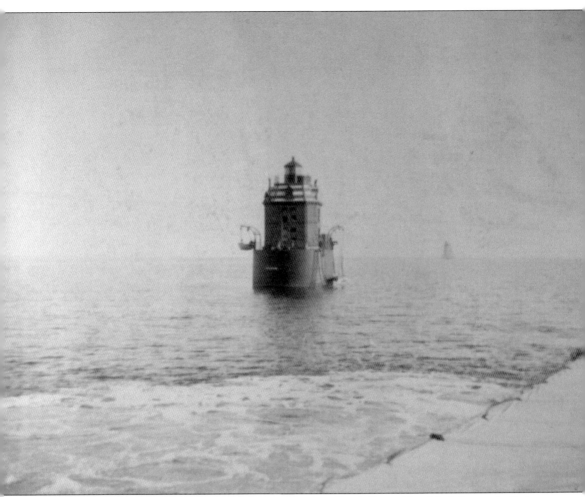

While this image depicts a caisson light tower, the first Sandy Point Shoal lighthouse, built in 1857, was a brick Victorian dwelling on land with a tower in the center extending through the roof. Both the light and fog bell were deemed ineffective—particularly during foul weather—because of their distance from the dangers of the shoal, so an offshore caisson appropriated by Congress in 1882 was sunk into the shoal itself at the southern mouth of the Magothy River just north of Annapolis. An octagonal brick tower rests upon an iron cylindrical sheathing over a wooden caisson. In 1890, the exposed brick was painted for protection after an inspection noted deterioration from the salt and exposure to the elements. The light marked the dangerous Sandy Point Shoal as vessels made their way beyond the Severn River and Annapolis toward Baltimore. The caisson incarnation is still serving just north of the Bay Bridge and can also be viewed from Sandy Point State Park. (National Archives.)

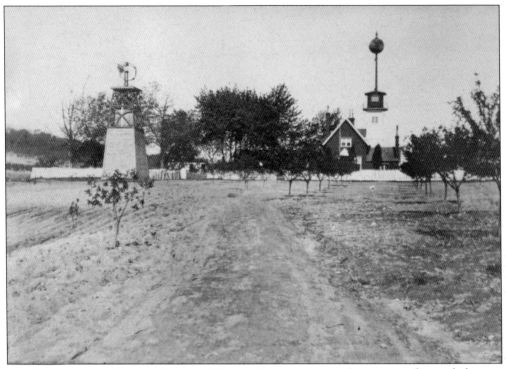

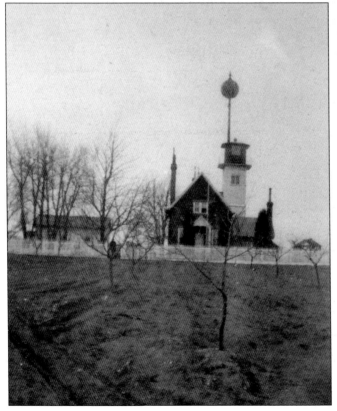

A new pair of range lights into Baltimore was erected in 1868 on the western shore of the Patapsco River near where the Francis Scott Key Bridge currently crosses. Leading Point served as the taller rear light, "being exactly in range with the axis of Brewerton Channel," according to the Lighthouse Board Annual Report. Leading Point featured a brick light tower through the roof of the land-based dwelling. A freighter exploded in the channel in March 1913, damaging both range lights and the Fort Carroll light, and blowing out glass from the lanterns. The wreck was eventually removed and the light stations repaired. Neither range light is still standing. (National Archives.)

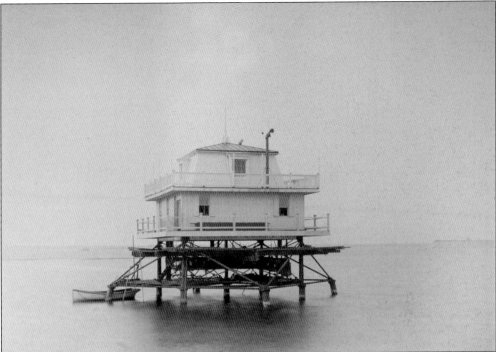

The front light of the Brewerton Channel range sat in water approximately one mile from Leading Point. As far a screwpiles go, the superstructure featuring a two-story square dwelling on Hawkins Point Lighthouse was unique. According to the Lighthouse Board, "When a vessel is on the true course coming up or going down the channel, the three lights will be seen in a line, one above the other; but whenever this course is departed from, however slightly, to port or starboard, a corresponding change in positions of the lights will be observed." The lights were renamed the Brewerton Channel Range Lights in 1915, when a single keeper was appointed to care for both. The land owner sued for rights to build a wharf that would block the view of the range and lost. (National Archives.)

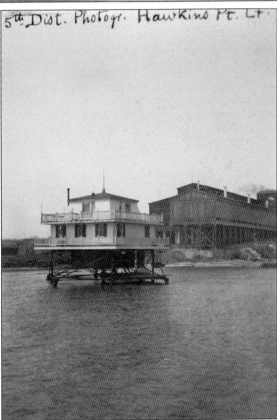

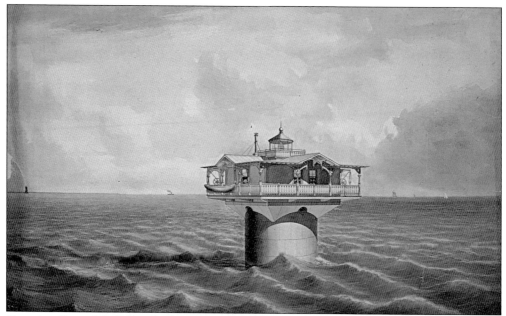

Occasionally mislabeled as the first caisson in the United States, the Craighill Channel Lower Range Front Light Station was the first caisson built on the Chesapeake Bay and second in the United States. A caisson was chosen after an especially brutal icy winter, and board members felt it would withstand ice better because of the exposed location offshore from North Point. The discovery of especially soft bottomlands initially hampered construction. To compensate, the caisson rested on wood piles driven 60 feet below the surface. The light station features two lights: a shorter, flashing range light that mariners line up with the taller rear range light and a typical navigational lantern at its peak. Resembling the picture below, these appear to be concept drawings before construction was completed in 1873. The front range light is still standing. (National Archives.)

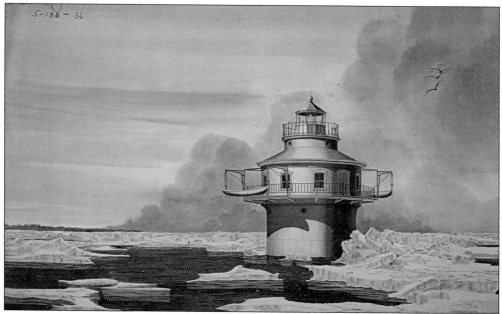

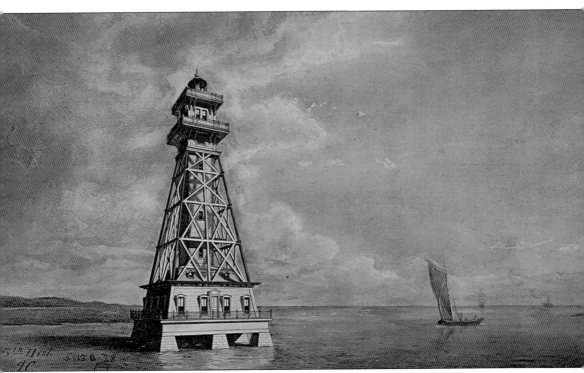

The Craighill Channel Lower Range became the third pair of range lights marking the route into Baltimore, even though the lighting of the Craighill Channel Lower Range put the early North Point Range out of commission. Named after William Price Craighill, a major in the Army Corps of Engineers and the Baltimore District engineer, Craighill proposed a new cut from the Brewerton Channel running due south for three miles. The new Craighill Channel, ready in 1869 but continually improved, saved five miles off the approach to Baltimore and avoided common dangers to ships approaching from the south. Piers for the rear skeletal range light were made of Port Deposit granite from near Havre de Grace. Also known as the Millers Island Light, the light station originally boasted a romantic Victorian keeper's dwelling at the base. The skeletal tower portion of the lighthouse still remains and functions as the taller rear light. (National Archives.)

Despite the name "upper," the Craighill Channel Upper Range is actually situated south of the "lower" range since it is the second range to appear in sight in the Craighill cut-off channel (also referred to as the Cut-off Range Lights). The rear light exhibited a locomotive light from the taller skeletal tower. Both range lights are still active aids to navigation, although no dwelling still exists. (USCG.)

The new range's short brick front tower squats upon the foundation of the former eastern North Point Range light. A foot bridge connecting the shore-based keeper's dwelling to the lighthouse washed away during a storm, so the light was affixed externally, and the keeper moved into the tiny structure. (USCG.)

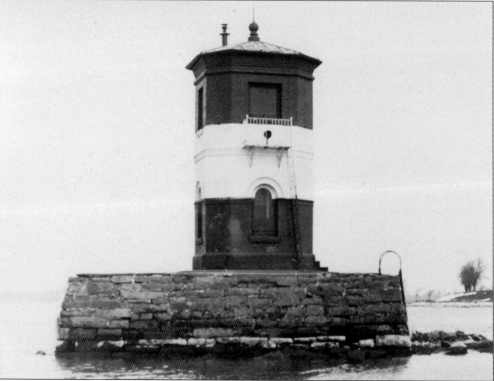

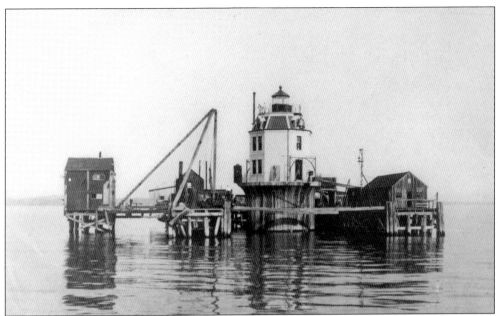

Illuminating the long span between Sandy Point and the Craighill Range, Baltimore Light was sunk at the mouth of the Magothy River, marking the beginning of the Craighill Channel. The first contractor abandoned the project after attempts to sink the caisson failed and left it sideways in the water. It was many months before the surety company erected a temporary worker's pier to complete the job. (USCG.)

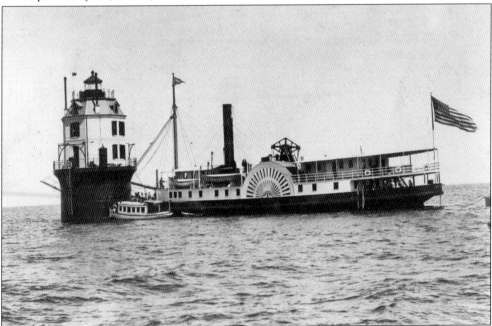

Murphy's Law definitely ruled mightily during the mishap-prone phases of construction. Baltimore Light became the last lighthouse built to mark the channels to Baltimore and also the last caisson constructed and sunk into Maryland waters. Initially towed to the site in 1904, the enormous structure didn't exhibit a light until 1908. Tender *Holly* is seen paying a visit. (USCG.)

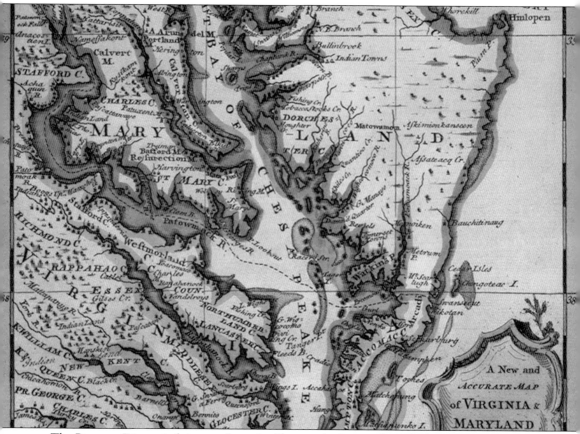

The Potomac River winds its way from the Chesapeake Bay up through the nation's capital and beyond the fall line. The river played a prominent role during the Civil War, yet few lighthouses had been erected on it at that time. Point Lookout and Blakistone Island were left with the scars of war for their parts. The lightships marking Upper and Lower Cedar Points were in place and destroyed. After the war and under the administration of the Lighthouse Board, many screwpile light stations were added to mark the winding curves and shoals in the river, particularly as passenger steamship traffic increased. (Courtesy of the Maryland State Archives Special Collections [Huntingfield Corporation Map Collection of the Maryland State Archives] Fielding Lucas Jr. "A Chart of the Chesapeake and Delaware Bays, 1832" MSA SC 1399–1–295.)

Three

THE MIGHTY POTOMAC

Maryland became a state of divided allegiances during the Civil War. Communities were divided with sympathies aligning with those of their neighbors. Since commerce between states had been steadily growing and expanding to international ports from many of Maryland's commercial hubs, the area suffered economically during the war.

The most compelling yet horrifying story of Maryland's Potomac River lighthouses took place at Point Lookout. The station served many functions during its lifetime in government service, but became notorious for being the site of a hospital and Confederate prisoner camp. As the war dragged on, rations to camps such as Point Lookout's thinned, leaving many prisoners to die of starvation and disease.

Over 20,000 prisoners were held at a time in miniscule tents on the property, and at least 4,000 died during internment. Stories indicate that some prisoners also may have been held within the lighthouse dwelling. A female keeper, Pamelia Edwards, must have had a rough and tough exterior to survive among the officers and prisoners during her tenure.

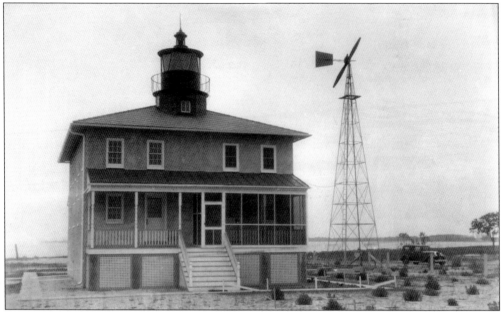

A one- to one-and-a-half-story keeper's dwelling with integral rooftop lantern built by the ever-present John Donahoo began marking the northern point of the Potomac River entrance in 1830 after years of haggling over land value. Initially, Point Lookout was reportedly built like Fog Point across the bay. This photograph by Maj. Jared A. Smith shows how it expanded up and back by July 1885. (USCG.)

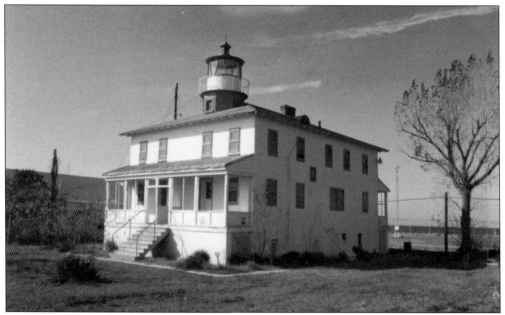

James Davis became the first keeper appointed to Point Lookout in 1830, but he died after only a few months at his post. His daughter Ann Davis took over and served until her own death in 1847. Martha Edwards maintained the lighthouse in 1853 after her keeper father died a few months following appointment. Her sister Pamelia took over two years later and held the post through the Civil War. (USCG.)

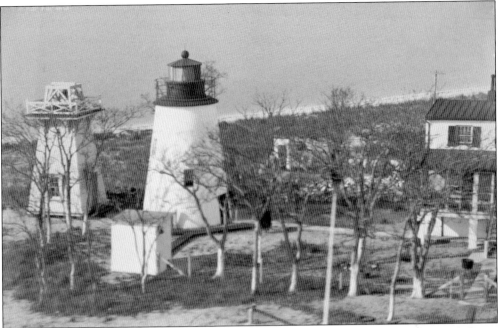

Another conical brick tower with detached dwelling built by John Donahoo in 1836, Piney Point sits 14 miles from the Chesapeake Bay on the Potomac River. Often visited by presidents, it earned the nickname the "Lighthouse of Presidents." A second story was added to the keepers dwelling in 1884. (USCG.)

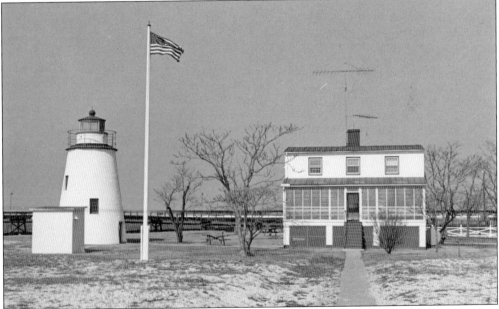

Angered that a contractor had not been hired to stem erosion threatening the lighthouse, Stephen Pleasonton removed keeper William Taylor from his post, despite letters praising his light-keeping abilities. Erosion protection measures progressed over the years. The navy intentionally sunk a captured German submarine off the point after World War II to test depth charges. Decommissioned in 1964, the lighthouse is still standing as a museum. (USCG.)

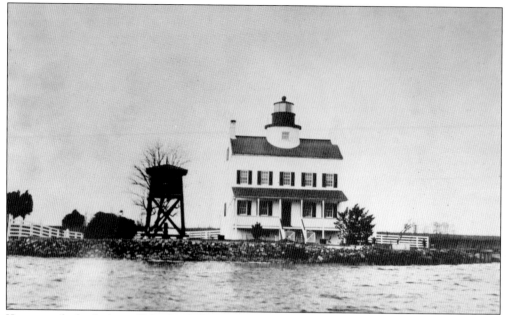

Known as the birthplace of Maryland, the first settlers landed in the state on Blakistone Island. The river island was originally and is currently known as St. Clements Island. Raiders led by a former island resident threatened to destroy the lighthouse during the Civil War, but keeper Jerome McWilliams pleaded to spare it for the sake of his extremely pregnant wife. (National Archives.)

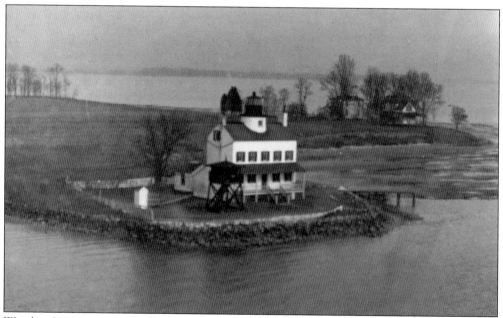

Winslow Lewis, more famously known for his monopoly over United States' lighthouse lighting apparatus with his shoddy Argand-style lamps with silver parabolic reflector design, may have designed Blakistone Island's tower-through-roof lighthouse, built by John Donahoo in 1851. Civil War raiders damaged the lantern and lens but spared the lighthouse from demolition, though it met a similar fate later. (USCG.)

Directly across the Potomac from George Washington's Mount Vernon estate stands Fort Washington, an army fortress built for defense of Washington, D.C., in 1814 and rebuilt in 1824. The first light was displayed in 1857 from a perch atop a pole. Permission to display the light was granted provided the keeper obeyed military command and the light be established on the wharf. (USCG.)

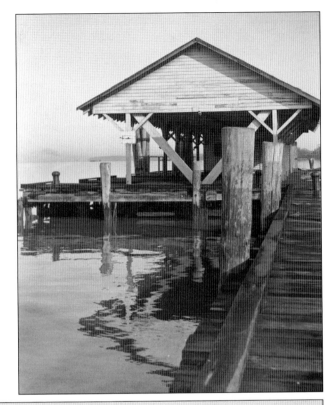

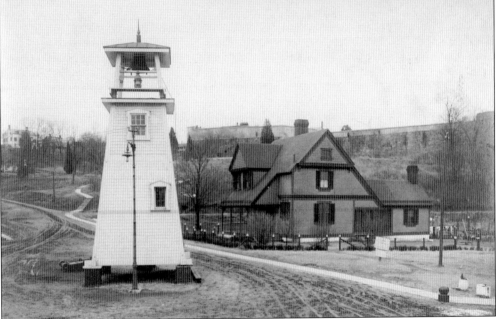

A light tower constructed at Lazaretto for the fort was erected in 1870 to brighten the oft complained about lantern, and a keeper's dwelling added in 1885. The taller 1882 fog bell tower ultimately became the host for the lantern. The bell tower was modified to support the weight of the lantern in 1901–1902. At some point, the keeper's dwelling was removed from the property. (USCG.)

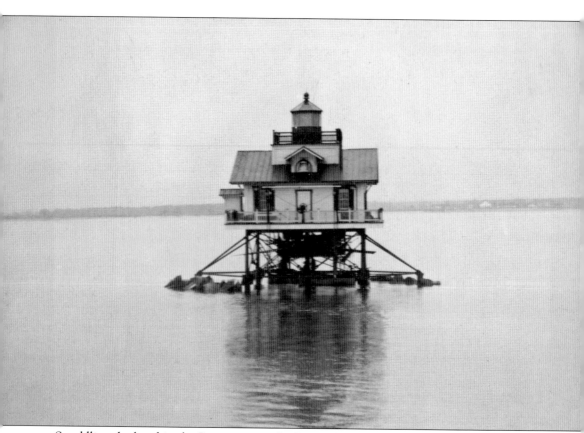

Straddling the bend in the Potomac near the Port Tobacco River, lightships originally marked the locations of Lower and Upper Cedar Point. Confederates burned both ships during the Civil War in April 1861, destroying them. In the Lighthouse Board's move to replace lightships with permanent structures, both Lower and Upper Cedar Point were chosen as sites for replacement, along with Janes Island and Hooper Strait on the Eastern Shore. Both sites received square wooden cottages placed upon screwpile foundations that were nearly identical in appearance in 1867. Over the years, uniquely identifying touches were added so the two could be distinguished more easily from each other. Lower Cedar Point followed in the wake of its previous lightship and was destroyed by fire in 1893. A rebuilt structure replaced the temporary light in 1896. Keeper L. E. Tillett lost a child by drowning during a family visit in 1920. (USCG.)

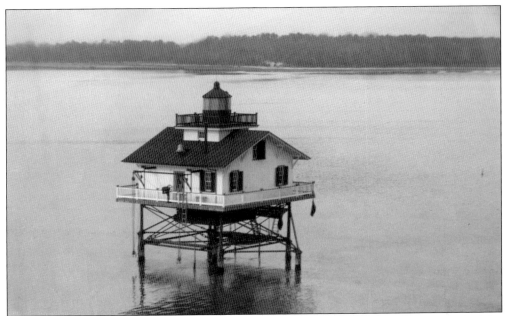

New lightships replaced those destroyed in 1864 at both locations before appropriation of the new permanent lighthouse structures. Aside from the loss of the lightships, Maryland suffered very little lighthouse damage during the war, a surprising fact in comparison to states farther south. One of the pair of square screwpiles was one of the few with African American keepers in the 1870s. (USCG.)

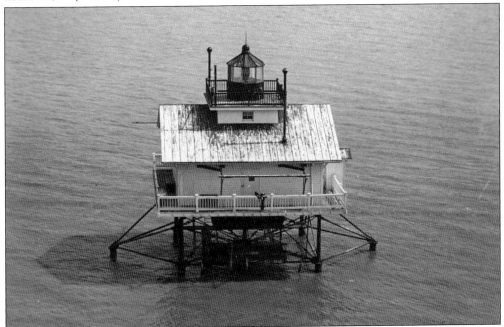

Lightships had served at Upper Cedar Point for 46 years, the longest duration for any station. With the lighting of Mathias Point in 1876, the Upper Cedar Point lighthouse was decommissioned. After complaints, service resumed in 1882. During the age of automation, a small light replaced the dismantled square cottage atop the screwpile foundation in 1963. (USCG.)

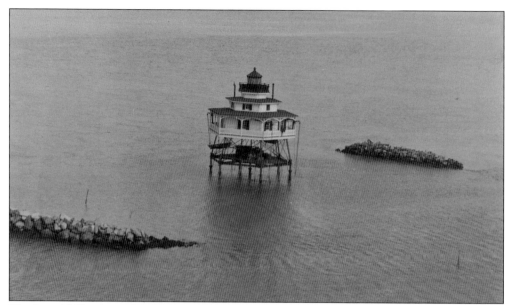

The beautifully unique Mathias Point hexagonal wood-cottage lighthouse, built in 1876 at the wide hairpin bend in the Potomac between the Upper and Lower Cedar Point lights, featured ornate woodwork and three levels in a tiered wedding-cake style. Initially the Mathias Point site was meant to only exhibit a day beacon with a screwpile designed for Port Tobacco Flats, but the sites were reversed, and this lighthouse was placed upon a skeleton tower on piles in three feet of water off the shoal. In January 1948, Coast Guard Cutter *Madrona* waited as the Mathias Point keeper lowered himself into a small boat to come aboard for evacuation during heavy ice. Heavy ice persisted for two weeks, and this tactic was employed at several Potomac River light stations during that period. (USCG.)

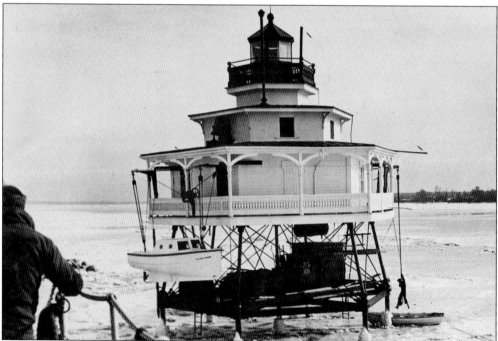

Thirteen years after the construction of Mathias Point Lighthouse, Cobb Point Bar Light went into commission in 1889. The light marked the entrance to the Wicomico River from the Potomac, five miles north of Blakistone Island. During this time period, passengers often traveled up the river on steamship lines. The bar, which extended five miles and was without marking, caused the grounding of many ships. (USCG.)

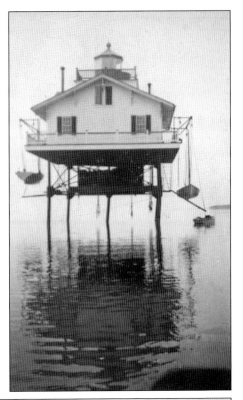

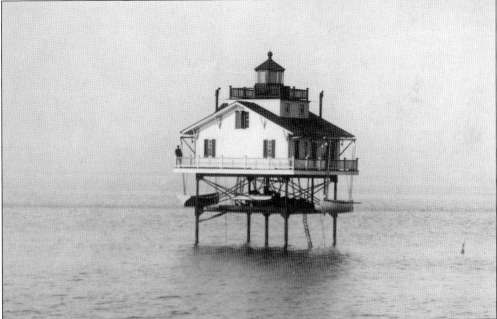

The spindly screwpile legs of Cobb Point were too long to go unbraced. Lower braces must have been installed, for the lighthouse survived until December 1939, when it suffered irreparable damage from a fire of unknown cause. It's possible the keeper may have accidentally dropped a cigarette into the tender pile below the dwelling. (USCG.)

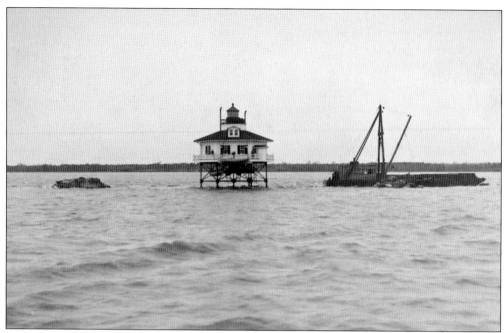

As the screwpile era began winding down, Maryland Point became one of the last few screwpiles erected in Maryland waters. The light station was erected in 1892 on an oyster shoal upriver from the Upper Cedar Point lighthouse, at a southern point where the river bends to jog north again. (USCG.)

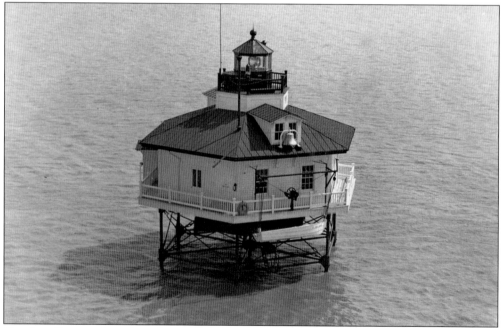

Five-foot-diameter discs slipped over the piles above the screws allowed for shorter yet stable piles. Still, the piles penetrated 13 feet into the shoal. The lighthouse was automated in 1954 and was carefully dismantled by the Coast Guard in 1963. Each piece was removed and taken to the Portsmouth, Virginia, depot. (USCG.)

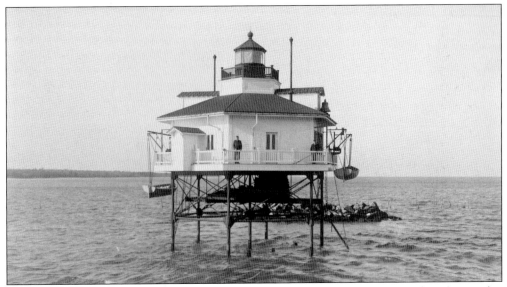

Notable as the last lighthouse built in Maryland waters and last screwpile on the Chesapeake, the Ragged Point Light began service in 1910. It was erected at a point on the opposite side of the Potomac just west of Piney Point. During an initiative to remove personnel and convert lighthouses to unattended operations, the station was proposed for automation in 1951. Prior to unattended operation, power cables needed to be run from shore to the lighthouse, requiring a right-of-way grant. The order submitted claimed the keeper would be reassigned to an active light station, although given the number of lighthouses converting to automation, at some point manned lighthouse availability would run out, putting keepers out of a career. (USCG.)

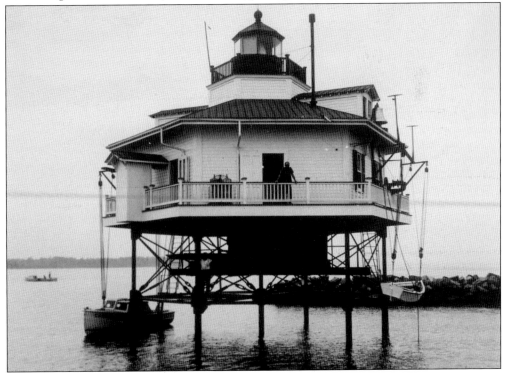

With myriad river entrances off the Chesapeake virtually indistinguishable from one another, particularly to navigators traversing the bay for the first time and mariners caught out on stormy nights, a system of marking the mouth of the Severn River and the Thomas Point Shoal to the south became the second priority in Maryland for Stephen Pleasonton after Baltimore received its first lights. Despite losing much of its harbor industry to Baltimore's deeper ports, Annapolis had become a well-populated seaport, with ships plying their trade all the way to New York. Oyster packing, ship building, and sail making industries thrived in the harbor. In addition, the Naval Academy was founded on 10 acres of old Fort Severn in 1845. Local agriculture and fishermen played a large role in early commerce. (Courtesy of the Library of Congress Historic Buildings Survey No. MD–329 conducted in 1980.)

Four

To Annapolis and Harbors South

The days of honorable duty as the temporary seat of the nation's government and that site of General Washington's resignation as Commander in Chief of the Continental Army in 1783 had long passed by the time lighthouses marked the route to Annapolis. Dark coastline stretched for miles on end, and shoals on either side of the bay had the potential to ruin a vessel's trip, particularly in foul weather.

The Thomas Point Shoal off the southern mouth of the Severn River proved particularly troublesome and became the first site to receive a light tower on shore. Rivers and tributaries also received lighted aids over time. These beacons served as general aids to traffic running up and down the Chesapeake and guides for ships turning into river-based harbors up the Patuxent.

The Chesapeake taught many of these early beacons important lessons about the powerful force of moving water. Early attempts to impede the advances of water toward light towers proved futile, partially because of the lack of innovation and funding under Stephen Pleasonton's regime.

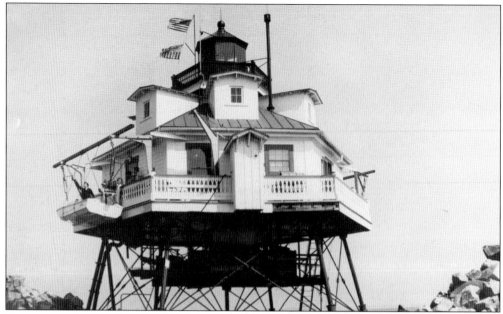

The current dormered screwpile often comes to mind when hearing about Thomas Point, but the first conical Thomas Point light tower built by Donahoo and Frieze stood on a point of land in 1825. Shortly after the first Maryland lighthouses were erected at Bodkin Point and North Point, John Donahoo and Simon Frieze built the original light marking the Thomas Point Shoal; they built the Poole's Island light at the same time. Erosion threatened the light tower quickly, so it was torn down and rebuilt by Winslow Lewis behind the keeper's house in 1840. In 1872, the Lighthouse Board determined that the light was "utterly useless" during fog because of its distance from the shoal, and plans to rebuild on the shoal called for a caisson after damage was done to Love Point during the winter. (USCG/National Archives.)

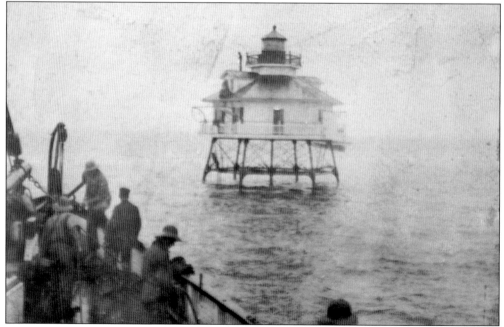

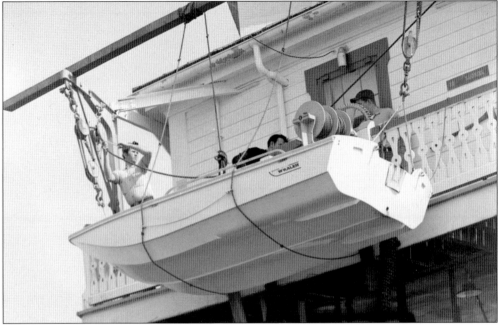

Costs associated with building and sinking a caisson proved too high at the time, so the board opted for a sturdier screwpile design instead. Hoping to avoid the known risk of ice to screwpiles, many protective measures taken over the years included installing a wrought iron ice breaker to the north of the foundation and mounding riprap around the structure. (USCG.)

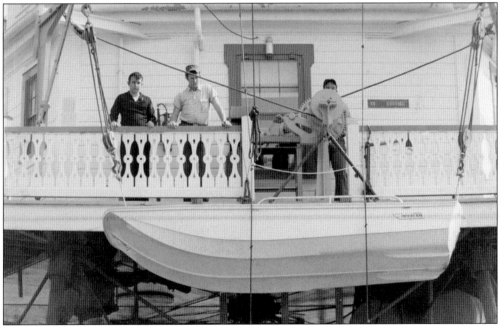

Offshore lighthouses in temperamental seas needed a secure way to tether boats. All offshore lighthouses employed a system of davits and winches to pull the boats appropriated to keepers out of the water to safety. Keepers often traveled alone in small boats during time off, risking their lives even in rough surf for a chance to visit their families. (USCG.)

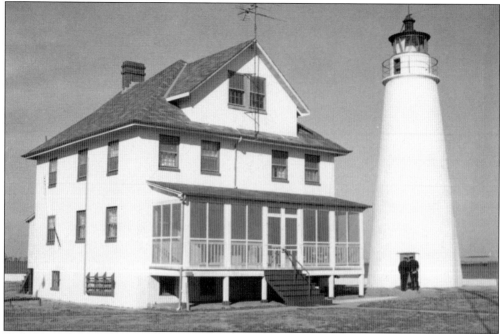

Built four miles north of the Patuxent River in Lusby on the southwest side of Maryland's portion of the Chesapeake Bay, Cove Point is another conical brick tower, erected by John Donahoo in 1828. Using locally manufactured brick, the tower originally stood 38 feet tall and was later raised to 51 feet around 1912. (USCG.)

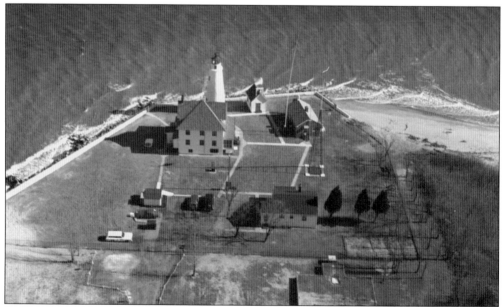

Still an active aid to navigation, Cove Point became the oldest operating lighthouse in Maryland when the Concord Point light in Havre de Grace was decommissioned in 1975. Poole's Island Light is also older, but it was decommissioned in 1939. Originally lit with an oil-fueled lamp, the tower received a Fresnel prism lens around 1890 to magnify kerosene and later electric lamps to 150,000 candlepower. (USCG.)

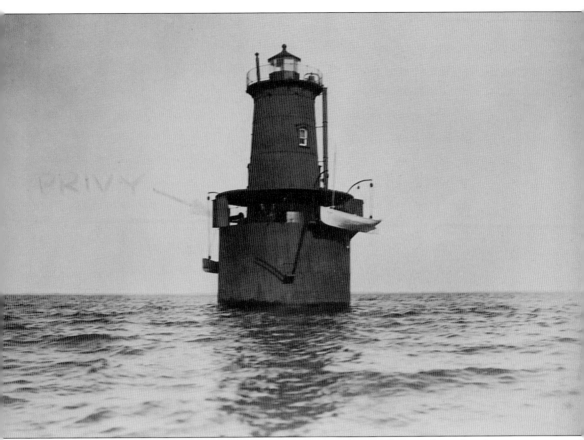

Pleasonton insisted the first Sharps Island lighthouse, a wooden dwelling with rooftop lantern built on the former 700-acre island, be built on wheels so it could be easily moved away from encroaching bay waters. As water crept closer to the land around the lighthouse, reports claim it was moved once in the 1840s, a feat many would love to witness to gauge just how easy the task was. Relenting to the incessant advance of waves and disappearance of the island, a screwpile structure was erected in 1866 just off the north end of the island. Ice swept the dwelling, and the two shocked keepers inside, north to Tilghman Island in 1881 until it ran aground. The keepers, thankful to have survived, were commended for sticking with their post throughout the wild ride. Maryland's second caisson became the third Sharps Island Light Station when it was completed in 1882, nearly a decade after the first caisson. (USCG.)

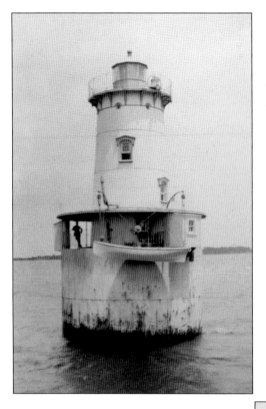

Built around the same time as the Sharps Island caisson due south, the dimensions and architectural style of Bloody Point Bar Light Station are nearly identical. Sunk off the southern tip of Kent Island to mark Bloody Point Bar, where tales of massacres and pirate hangings presumably lent the name, the brown iron tower also exhibited light for the first time in 1882. (USCG.)

This style of caisson is often referred to as a "coffee pot" or "spark plug" because of the skinny form of the tower atop the fatter caisson. The request for Bloody Point offered it as a potential backup should Thomas Point Shoal Light Station succumb to ice, since ships could make a straight run from Bloody Point to Sandy Point and avoid the shoal. (USCG.)

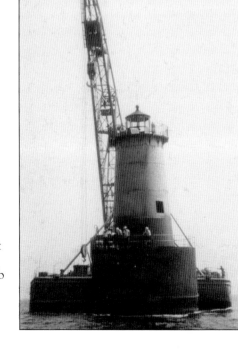

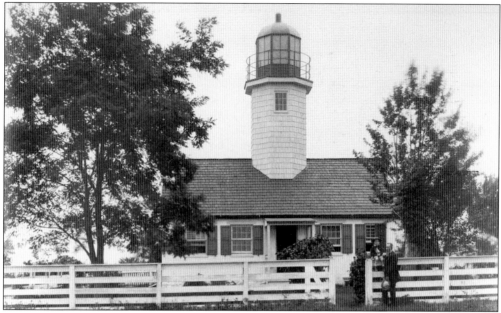

The unique fish weather vane and shingled rooftop lantern tower were the only distinguishing features of the shoddily constructed lighthouse built in 1848 atop the bluff at Greenbury Point on the northern side of the Severn River into Annapolis. Complaints that the light itself could not be distinguished from those at the Annapolis Naval Academy drew many complaints from mariners and rendered the light station ineffective. (National Archives.)

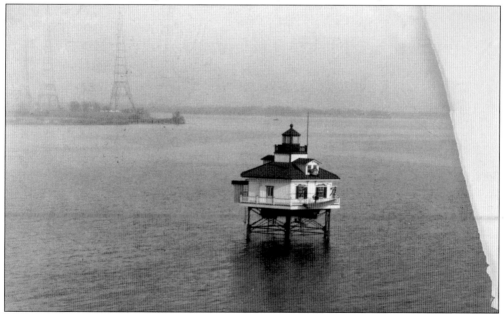

Abandoning the leaky, dim, land-based light station on the eroding point, the Lighthouse Board built a replacement hexagonal screwpile lighthouse in the water just off the point in 1891. The first Greenbury Point lighthouse eventually collapsed. Greenbury Point Shoal's construction also utilized the cast-iron disks slipped over the piles to give the structure more solid bearing. Today only the screwpile foundation remains. (USCG.)

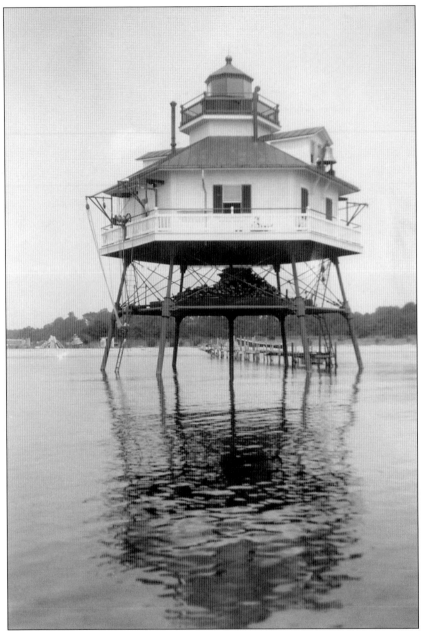

Range lights were originally requested to mark Drum Point at the entrance to the Patuxent River prior to the Civil War, but confusion ensued during the war, and nothing ever came of the appropriation. The lee created inside the river entrance provided ships refuge during foul weather, but many ran aground on the spit. The request was repeated and approved after the war, but funds appropriated only covered the cost of one lighthouse many years later. The Lighthouse Board determined the range Congress authorized was unnecessary in that location and proceeded with building a single lighthouse exhibiting a fourth-order lens 46 feet above the water. A hexagonal dwelling similar to Hooper Strait was erected in 1883 on seven wrought iron 10-inch piles at Drum Point. Initially the one-and-one-half-story cottage stood 70 feet offshore in 10 to 12 feet of water. (USCG.)

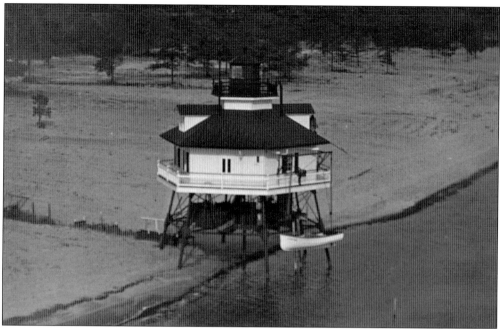

In an odd reversal of the usual pattern of erosion washing land lighthouses stood on away, the beach came to the offshore Drum Point screwpile. Other lighthouses, such as Cedar Point, could only dream of such good fortune, although in the case of Drum Point, attaining land meant nothing other than allowing easier access to vandals after automation. (USCG.)

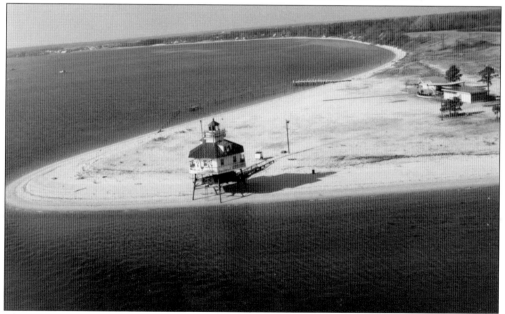

The automated Drum Point Light Station bid farewell to keepers in 1960. A lighted buoy replaced its functionality in 1962, and the station was discontinued as an active aid. Abandoned, the lighthouse incurred extensive damage until the Calvert Marine Museum moved the structure to a museum setting two miles away in 1974 and fully restored it, aided by the memories of a former keeper's daughter. (USCG.)

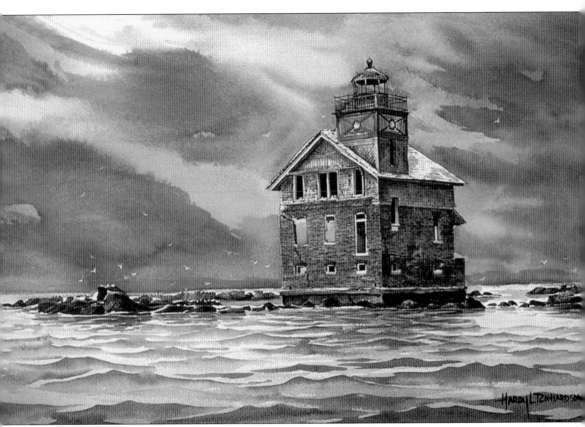

The Lighthouse Board requested a light station at Cedar Point, noting that the deep water turned abruptly shallow for vessels approaching from the south. The light could also be used as a general aid to navigation on the bay for ships traveling past the point. Across from Drum Point on the southern shore of the Patuxent River, the gabled Cedar Point lighthouse, constructed in 1896, stood on a peninsula of land. The roof peak featured a decorative sunburst pattern. The three-story brick-and-wood rectangular dwelling initially sat on 1.54 acres with the unique lantern offset on the roof of the dwelling. The board eventually sold most of the point of land to the Arundel Corporation. Over time, dredging and erosion turned the peninsula into an island until the lighthouse stood in the deepening water. (*Cedar Point Storm* courtesy of local artist Harry Richardson who created it from his boat in 1973.)

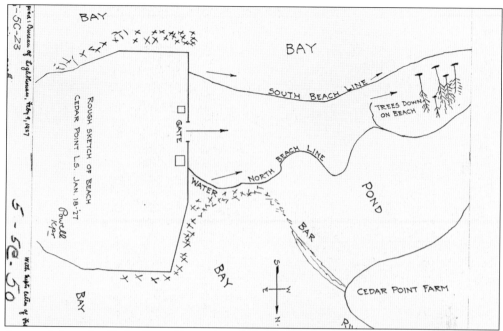

Accessed from the Cedar Point Farm, the original Cedar Point property hosted a small pond and two beaches. Over time, the spit of land providing access became a stream during high tide, later necessitating the use of a small boat to travel to land at all times. A child helping the keeper perished during one such crossing when he disappeared struggling to push a boat across. (National Archives.)

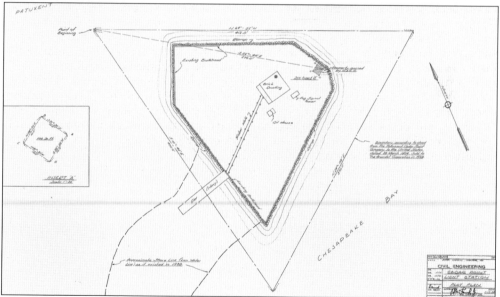

When built, and for the first decades of its short existence, Cedar Point Light Station also housed a fog bell tower with a summer kitchen and oil house, accessed via a boardwalk, and an outhouse, stable, and boathouse. The keeper reported that the boardwalk between the oil house and fog bell had washed away during a storm in 1912. The bell tower collapsed in 1957. (National Archives.)

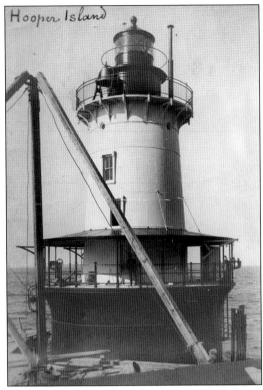

Hooper Island

Lit in 1902 southeast of Cedar Point and close to Hooper Island, a caisson lighthouse was erected to help light the 30 miles of shoals between Smith Island and Cove Point, which proved hazardous to larger draft vessels. At the time of its construction, locals may have known the Hooper Island Light as the "Old Barren Island Lighthouse," referring to the formerly populated island to the north. (National Archives.)

Historically lightships had marked the Hooper Island location until at least 1866. Using the pneumatic process to sink it, the tall caisson experienced little in the way of mishaps during construction. Personnel were removed, and the lighthouse was fully automated in November 1961. The gallery roof was removed sometime afterward. The original fourth-order Fresnel lens was stolen in the mid-1970s. (USCG.)

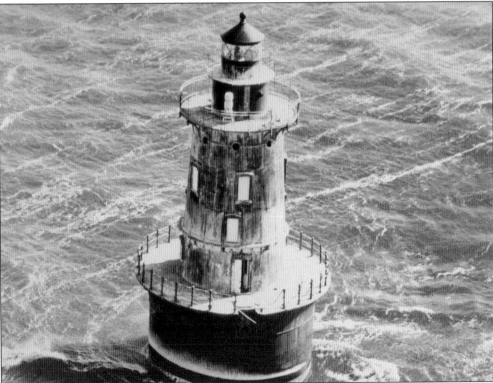

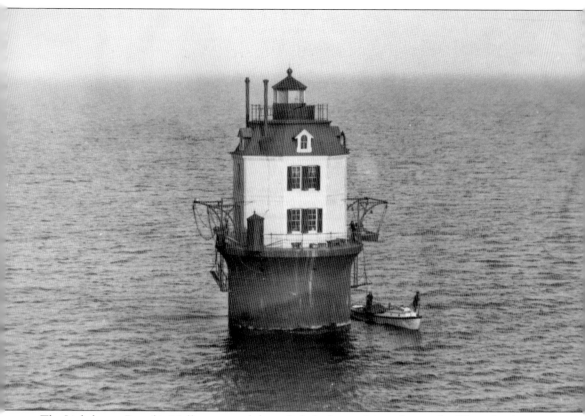

The Lighthouse Board initially requested that a light be located six miles north of Point Lookout in the approximately 30-mile stretch of unlit waters between Smith Point and Cove Point in 1891. They reasoned that if any ships with large drafts drifted off-course, they could become hung up on dangerous shoals. Initially $35,000 was appropriated for construction of Point No Point that never began, indicating a screwpile may have been intended. As years passed with the request unheeded, the board decided in light of recent damage to screwpiles, to only recommend caisson structures for sites where the danger of ice existed. Therefore, the price went up to $65,000 and construction finally began in 1902. Due to accidents occurring during the course of positioning the caisson at the chosen site, the lighthouse was not completed and commissioned until April 1905. (USCG.)

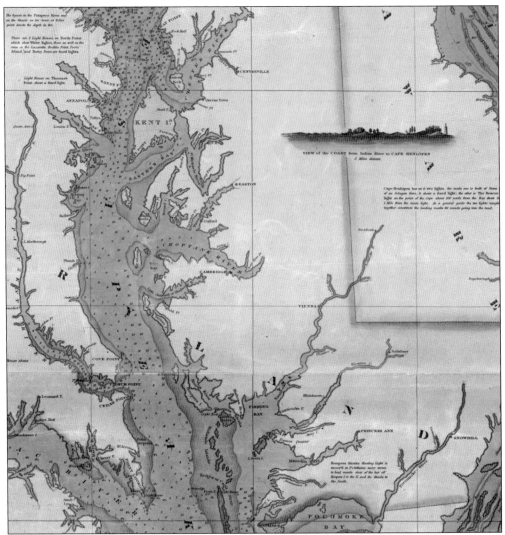

The land and islands on the right side of the Chesapeake, as seen in this 1832 map, make up the Eastern Shore of Maryland. An interesting note is that the island currently referred to as "Janes Island" is labeled "James Island" on this old map. Fishing and sales of fresh seafood encompassed the primary functions of the Eastern Shore, with Crisfield (formerly known as Annemessex and Somers Cove) holding the title as the primary oyster producer in the United States. Chestertown, up the Chester River, was home to a thriving port, only secondary to Annapolis. Many of the islands just off the shore were once largely populated and thriving communities until the bay began swallowing them up. (Courtesy of the Maryland State Archives Special Collections [Huntingfield Corporation Map Collection of the Maryland State Archives] Fielding Lucas Jr. "A Chart of the Chesapeake and Delaware Bays," 1832 MSA SC 1399–1–295.)

Five

EASTERN SHORE

Two early lights marking the Eastern Shore were Fog Point on Smith Island, built by John Donahoo in 1827, and Clay Island on the north side of the Nanticoke River, also built by Donahoo in 1832. By all accounts, the two lighthouses were one-and-a-half stories with an integral stone tower through the dwelling topped by a lantern on the roof. Keepers were paid higher wages because of the isolation of the remote locations.

Early lightships marked other Eastern Shore hazards, and a lighthouse structure wasn't built for another 35 years after Clay Island. The notably unreliable lightships were relied upon too heavily as aids for navigation.

Once the Lighthouse Board took over operations, one of their first moves was to make lightships identifiable. Until that point, lightships had no unique marks identifying them as aids to navigation. Eventually, the board set out to replace them, finding that the keepers had a habit of absenteeism and of pocketing the funds meant for crew.

Two of the new offshore lighthouses constructed put the Fog Point and Clay Island lights out of commission. Both were quickly consumed by the elements after retirement, and no evidence of them remains.

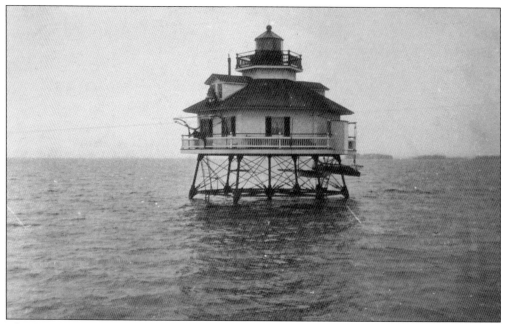

The first Hooper Strait sleeve-pile lighthouse, built in 1867, was nearly identical to the one erected at Janes Island. Both were built at the same time after their lightships were selected for replacement. Floating ice sent the dwelling adrift in January 1877. This undated photograph is not likely the original screwpile. (National Archives.)

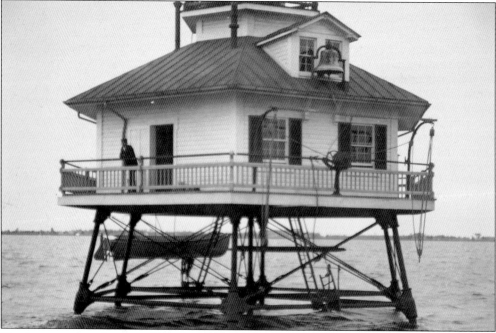

The keepers narrowly escaped by taking what little they could and pulling it in a boat across the ice. A lighthouse tender retrieved the lantern and lens among other objects from the wreckage, and a new, stronger screwpile was erected in 1879 using 10-inch, wrought iron piles with the intention of resisting ice better. (USCG.)

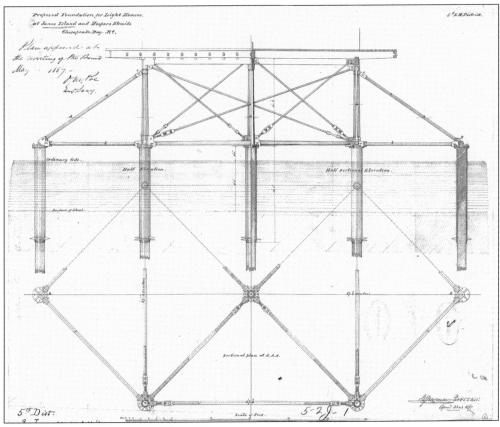

Also at the entrance to the Little Annemessex River is Janes Island, known as "James Island" for many decades. Initially lighthouse construction plans were scrapped, and a lightship marked the bar in 1853. A square screwpile design nearly identical to the first Hooper Strait lighthouse was selected to replace the lightship. Fitted with a fourth-order Fresnel lens, the lighthouse was first lit in 1867. (National Archives.)

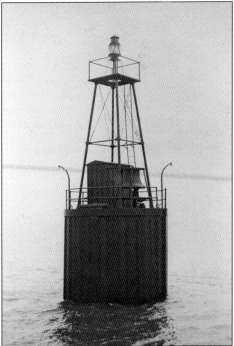

The lighthouse lasted only 12 years before ice demolished it in January 1879. A sturdier screwpile constructed the same year suffered reparable ice damage in 1893 before completely succumbing in 1936. Keeper Luther E. Bozman followed orders to abandon and walked across ice to shore just before the cottage was swept away—an act that saved his life. This caisson with skeleton tower replaced it and has remained since. (USCG.)

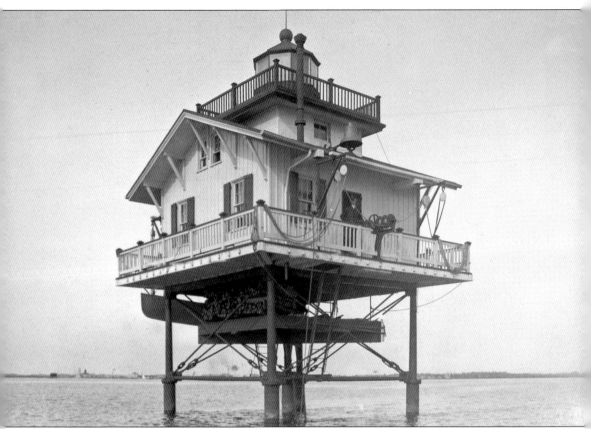

Little did the Lighthouse Board realize how important history would be to later generations. Little historical documentation remains of the quaint square sleeve-pile Somers Cove Light. Considered of such little consequence when it was built in 1867 for a mere $10,000 and fitted with the smallest (sixth-order) Fresnel lens, this light isn't documented aside from this August 20, 1915, photograph, which shows the keeper under the fog bell and the store of firewood underneath the dwelling. Situated just north of the Virginia line on the eastern side of the Chesapeake Bay, the light marked the harbor to Crisfield, Maryland. The Somers Cove light was dismantled in the 1930s, leaving only the foundation with a flashing white light, and renamed the Little Annemessex River Light No. 7, while the phrase "Somers Cove" now refers to the harbor of Crisfield itself. (USCG.)

In 1871, the Choptank River wood-frame cottage was erected on sleeve piles. Ice floes tipped the dwelling slightly in 1881, prompting the keeper to flee. Damage was not structural, and the keeper was asked to resign. Destroyed by ice in 1918, the decommissioned superstructure from Cherrystone Bar in Virginia was placed on the foundation in 1921. This was the only instance where one structure replaced another. (USCG.)

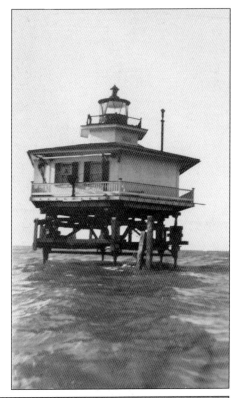

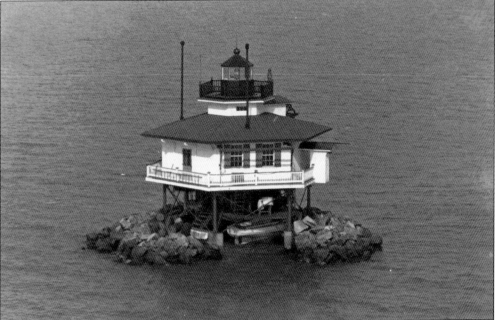

Built in 1871 by the same builder of the Choptank River lighthouse, Love Point sat off the northern tip of Kent Island. Meant to mark a shoal and guide ships into the Chester River, it exhibited a unique and powerful 3.5-order Fresnel lens. The lighthouse suffered ice damage that extinguished the light for several days its first winter. Both dwellings were dismantled in 1964. (USCG.)

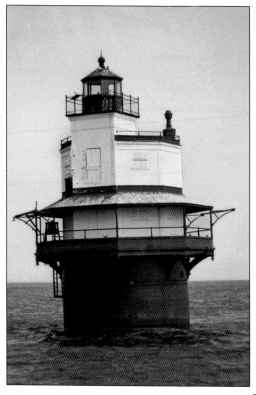

The Fog Point lighthouse was considered weak and ill-positioned. The one-story, saltbox-style dwelling encompassed a stone tower through the roof and was left abandoned once the first Solomons Lump screwpile began service in 1875, rendering Fog Point obsolete as a navigational aid. No photographs of Fog Point appear to exist, and this caisson eventually replaced the Solomons Lump screwpile. (USCG.)

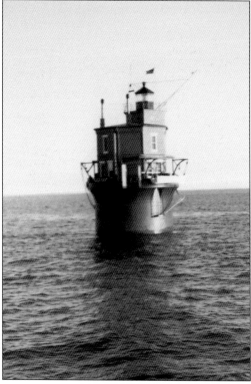

Ice shoved the square structure off its screwpile foundation, partially submerging it, in January 1893. The board decided to replace it with an ice-resistant caisson. Stepping away from the traditional ironclad superstructures often erected atop iron-plated caisson foundations, the Solomons Lump steel-and-iron foundation supported an offset brick light tower enclosed on three sides by the hexagonal wooden dwelling. It was completed in 1895. (USCG.)

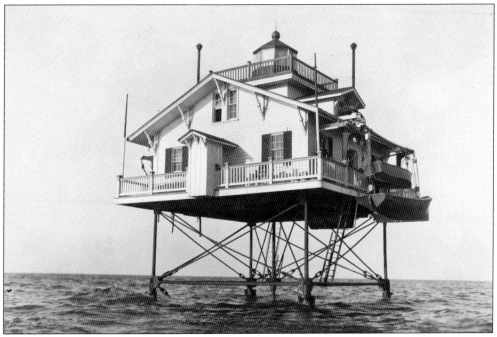

One of the few screwpiles shying away from the typical hexagonal cottage style, the square dwelling of Great Shoals was fabricated at the Lazaretto Depot in Baltimore during the first half of 1884 then disassembled and reassembled at the site less than a month after the first pile was driven in July. The Great Shoals Light Station guided ships into the Wicomico River's narrow channel on the Eastern Shore upriver toward Salisbury with a fifth-order lens 37 feet above sea level in a nine-sided lantern. The seven-room lighthouse, no longer manned, was dismantled in 1966. (USCG.)

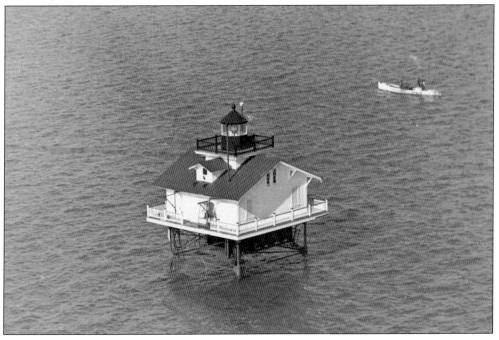

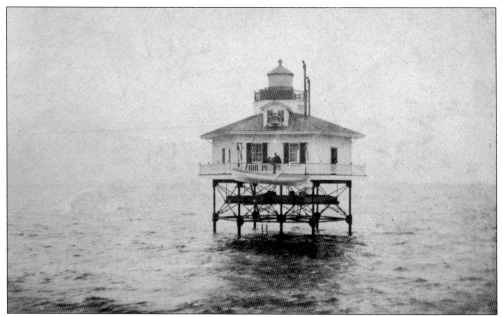

Located northeast of Point Lookout across the bay, the hexagonal screwpile Holland Island Bar Light Station stood in 9 feet of water just west of Holland Island from 1889 until it was replaced with an automated beacon in 1960. The light exhibited from 37 feet above water and flashed white twice every 10 seconds with a range of 12 miles. The dwelling was partially constructed at the Lazaretto Depot in Baltimore at the same time as Virginia's Great Wicomico River light station, and was lit two weeks later. The lighthouse stood witness to many bizarre events over its years of service. (National Archives/USCG.)

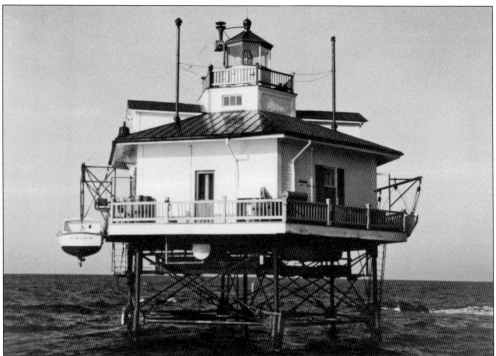

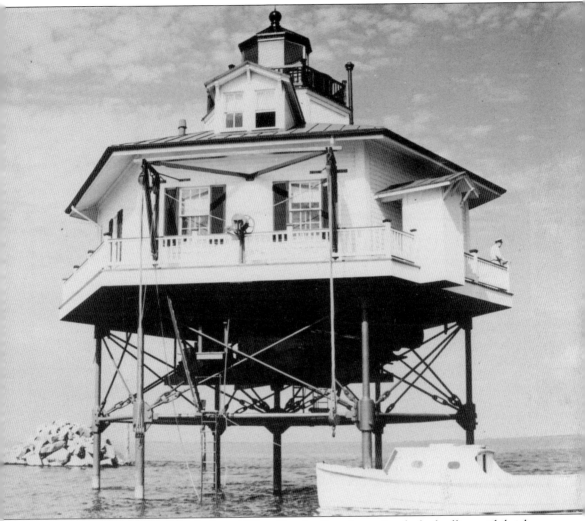

The Clay Island Light Station, built in 1832 in Tangier Sound, consisted of a dwelling with brick light tower up the middle. It became a victim of erosion as the island washed away, repairs became too expensive, and a new lighthouse was proposed slightly southwest of the light on a shoal in 1891. Construction of the wooden, hexagonal Sharkfin Shoal dwelling took place at the Lazaretto Depot in Baltimore alongside Greenbury Point Shoal Light (also being built to replace the land-based Greenbury Point light succumbing to erosion). The superstructures of the two lights were nearly identical, and the new Sharkfin Shoal Light Station went into service in 1892, just in time, since the Clay Island structure collapsed in 1894. The same story of automation can be relayed as the dwelling was dismantled in 1964 and replaced with an automatic beacon. (USCG.)

TAKEN JAN. 1933 BY R.C. SMITH.

C.&D. CANAL LT. #8, 1938

The Chesapeake and Delaware Canal began serving shipping traffic in 1829 at the far northeastern corner of the Chesapeake Bay. The 14-mile-long canal connects the Chesapeake Bay from the Elk River to the Delaware River. As ship sizes increased with the addition of steamers and later freighters with deeper drafts, the canal needed improvements. Railways were also competing for traffic and revenues. The federal government purchased the canal in 1919 for $2.5 million and made necessary improvements, reopening the canal in 1927. In the 1930s, a federal navigation channel from the Elk River to Poole's Island aided ship commerce. (USCG.)

Six

NORTHERN CHESAPEAKE BAY

The Chesapeake's system of navigation didn't end with the northern port of Baltimore. Vessels traversed the uppermost reaches of the Chesapeake to ports such as Havre de Grace up the Susquehanna River. Once opened, the Chesapeake and Delaware Canal cut 300 miles off trips to the Atlantic, making shipping by sea more economical and competitive with railways. Trade routes were established to New York and across the Atlantic.

Few lights were required north of Baltimore, and John Donahoo built all four. Donahoo died a year after completing his last lighthouse on the island of Fishing Battery.

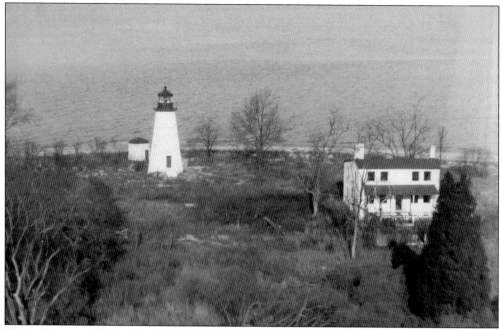

Simon Frieze and John Donahoo constructed the Poole's Island stone tower and dwelling on Poole's Island north of Baltimore while also constructing the first Thomas Point lighthouse south of Annapolis in 1825. The tower was constructed out of granite from nearby Port Deposit. The one-story dwelling was expanded to two full stories in 1882. (USCG.)

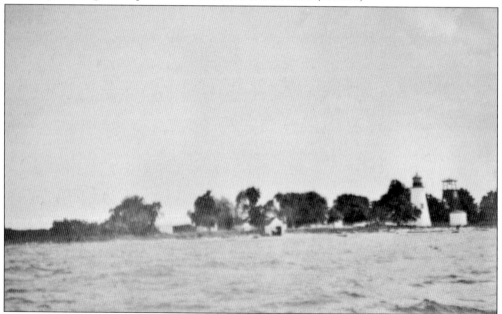

Now owned by the army as part of Aberdeen Proving Ground, the island is off-limits to the public and fenced off. Automated in 1918 and deactivated in 1939, the oldest Maryland stone tower still stands, but undetonated ordinance may still exist and pose a danger on the grounds. The dwelling and outbuildings were torn down after the island became military property in 1917. (National Archives.)

John Donahoo, an active member of Havre de Grace town and politics, was awarded the honor of constructing this conical stone tower in his own hometown in 1827. Due to difficulties securing enough land at the water's edge, a separate parcel purchased for the keepers dwelling gave new meaning to the description "detached." (USCG.)

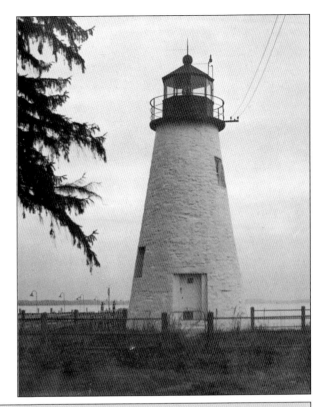

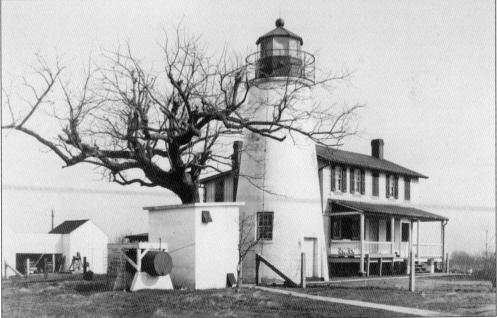

The tapering light tower built atop a bluff on Turkey Point marked the change in course toward the Elk River and newly completed Chesapeake and Delaware Canal and offered the tallest focal plane of any Maryland lighthouse at 129 feet above the water. Donahoo constructed the light tower and keeper's dwelling in 1833. (USCG.)

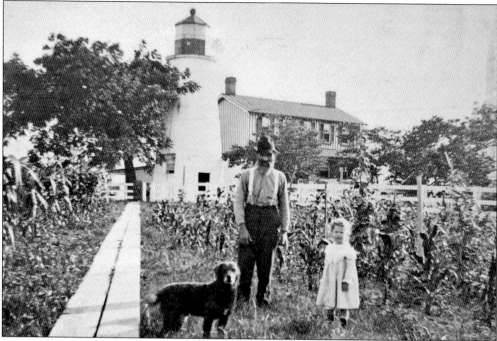

Famous for being tended by Fannie Mae Salter, the last female lighthouse keeper in service in the United States, Turkey Point has a long history of female keepers. Children grew up on the largely self-sufficient four-acre plot of land where keeper families raised sheep, turkeys, and farmed and preserved their own vegetables for the winters. (National Archives.)

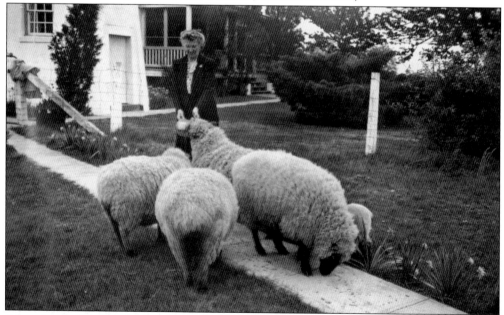

After the death of her husband, the appointed keeper of Turkey Point, in 1925, Fannie Mae Salter requested the position. A directive prohibiting the appointment of keepers her age required President Coolidge to authorize the appointment. She held the position for 22 years, raising her young son at the lighthouse, until she retired in 1947 at the age of 65. (USCG.)

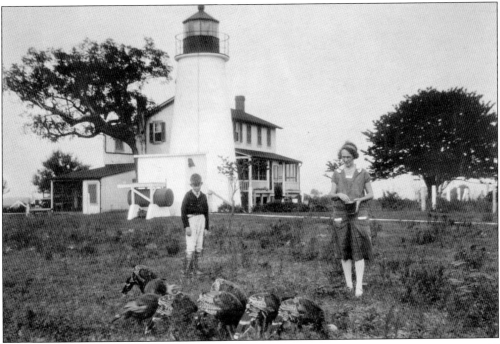

An active aid to navigation for over a century, beginning in the earliest era of Maryland lighthouses, when lamps burned oil with multiple wicks requiring constant trimming and attention, Turkey Point experienced many changes over the years. The advent of electricity and auxiliary backup equipment reduced lamp-tending down to the flick of a switch. Automated in 1948, the light tower continued service as an aid to navigation until April 2000. The dwelling and outbuildings were torn down in 1971 after years of neglect, and the staircase was removed from the light tower to discourage vandals. The tower now sits on the Maryland Department of Natural Resources Elk Neck State Park. (USCG.)

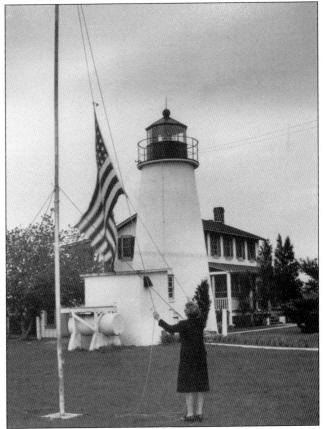

In addition to his reputation as the premier lighthouse builder, John Donahoo ran a fishing business from a man-made island he once owned, known as Fishing Battery and situated south of Havre de Grace. Fishing Battery became the site of the last Maryland lighthouse built under Stephen Pleasonton's administration and the place where Donahoo built the last of his 12 lighthouses, which he did at age 65 in 1853. Donahoo worked out the sale of the land from Scott Otho, a business partner. He began laying the foundation for Fishing Battery Light Station prior to finalization of the sale. A second story was added to the dwelling during the 1880–1891 period, when the federal Bureau of Fisheries leased the island. The light was transferred to the pictured steel tower, erected in 1921. (USCG.)

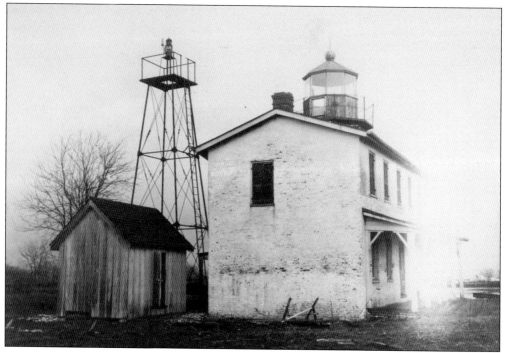

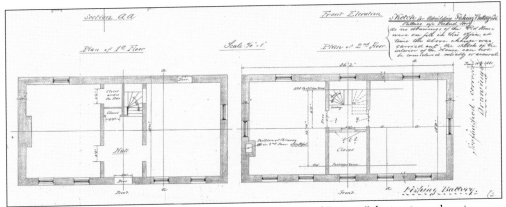

The island was also known as "Donahoo's Battery" and "Shad Battery" during its early existence. These drawings from June 10, 1881, have a note saying, "as no drawings of the old house were on file in this office at time the above change was carried out, the sketch of interior of the house can not be considered reliable or accurate," and was likely created during the time the second story was added. The simple sketch below is dated September 4, 1862, and shows the one-and-a-half-story dwelling, although it appears to be up on a pier of some sort. (National Archives.)

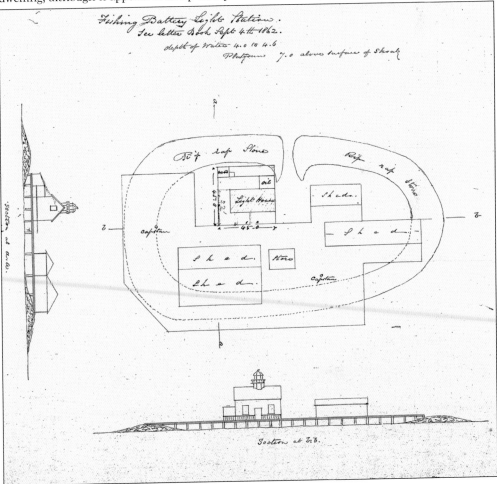

TREASURY DEPARTMENT
U. S. COAST GUARD
CG-2548 (Rev. 2-52)

RECORD OF INSPECTIONS

INCLUDING INSTRUCTIONS FOR
OFFICER-IN-CHARGE

COAST GUARD LIGHT STATION THOMAS POINT SHOAL
(Name of unit)

5TH CG District. From DECEMBER, 1970

to November, 1972

U. S. GOVERNMENT PRINTING OFFICE 16—19079-1

RECORD OF INSPECTIONS
(SEE INSTRUCTIONS ON INSIDE FRONT COVER)

Station inspected 11 December, 1970

Inspection made by R. G. Corrolino

Instructions to Officer-in-charge as to condition of station, special work to be attended to, etc.,

Conducted quarterly inspection this date accompanied by RMC SHULTE and BM1 Loving. Material conditions good, maintenance program very effective. Several items submitted on SSMR program pend especially repairs to roof. Housekeeping and general appearance is excellent. Boat is maintained well. Communication procedures are good. Several items will be noted on inspection report requiring Group action.

R G Corrolino LT USCGR

STATEMENT BY OFFICER-IN-CHARGE

(Officer-in-charge will state hereon action taken on above instructions, and give date of completion of repairs, etc., if any were ordered.) LIST OF DEFICIENCIES CORRECTED

BM1 Alonzo O. Burroughs
(Signature of Officer-in-charge)
23 DECEMBER, 1970
(Date)
16—19079-1

Inspection records and log books often recorded day-to-day maintenance records and mundane notes of repairs and restocking of provisions. Some keepers occasionally recorded weather conditions, adding a little personal flair. The stories the official books don't hold are the ones passed down from families and friends of keepers, adding character and emotion to the histories. During the early era of lighthouse tending, the post was not considered glamorous or honored, so early journalists did not seek out the stories. As time went on, local papers began reporting on extraordinary occurrences at light stations and interviewing men and women who spent decades in the service. (USCG.)

Seven

Death, Murder, and Bombs
Tales of Interest

Tending offshore lights was no simple task and often led to unusual and unexpected events, many tragic. Keepers often risked their lives to rescue capsized boaters and passengers. Occasionally their own lives were at risk simply because of the job they committed to—keeping the lights lit at all times. Brutal winters that froze the bay held keepers prisoner in their lights. A descendent of a Craighill keeper told the story about his ancestor running out of food during a bad freeze and perishing of exposure to extreme weather while trying to walk across the ice to land.

The Prohibition era would only be an amusing footnote in the history of lighthouses, worthy of mention only because forbidding the sale of alcohol was written into keepers' contracts. Yet Prohibition may have played a deeper role in the tale of keeper Ullman Owens of Holland Island Bar Light.

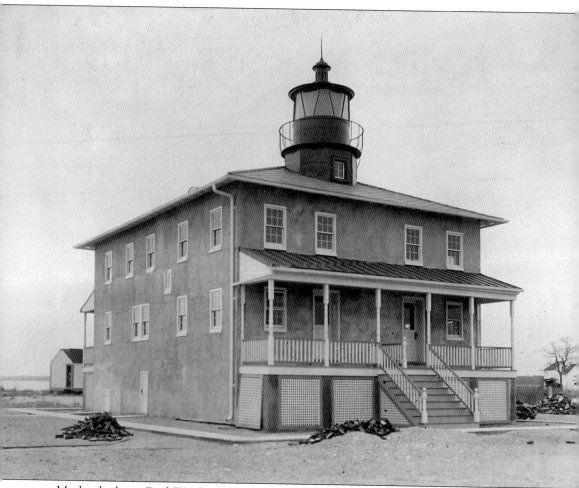

Maybe the large Civil War hospital and prisoner camp where 4,000 died and were buried close to the lighthouse left tortured souls on the property. Stories also say that prisoners were held against their will in the Point Lookout dwelling itself. Several witnesses have reported seeing apparitions on the grounds and inexplicable experiences inside the lighthouse, such as a baby being turned around in its crib, blanket and all. Another reported ghost might have been a Mr. Haney, who attempted to row to shore from the sinking steamship *Express* during a storm in the fall of 1878 and never made it. Many paranormal investigations have occurred at the site and claim to have recorded over 20 distinct voices of officers and possibly seen the ghostly form of keeper Ann Davis herself. Erosion threatened the graves, and breakwaters were installed around the lighthouse. The graves were relocated farther inland, yet that doesn't appear to have stopped otherworldly visits to the lighthouse location. (USCG.)

Two young keepers experienced the drama of a lifetime while tending the Bloody Point Light Station in 1960. An electrical fire began and spread to propane tanks, giving the men just enough time to jump into their launch and escape after attempts to battle the blaze proved futile. They barely succeeded, as the launch didn't float free initially, and one keeper was burned. The tanks exploded, gutting the light's interior. (USCG.)

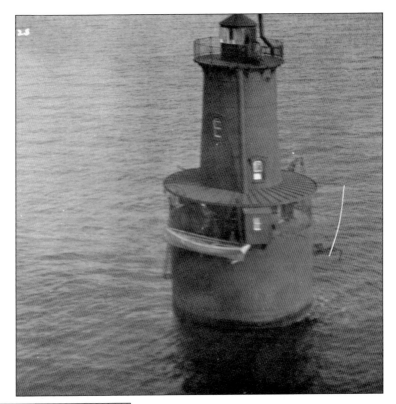

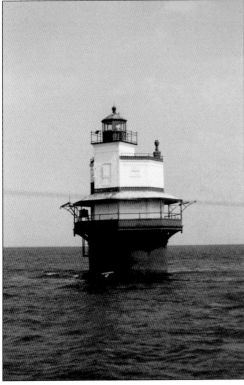

During the heavy ice storm of 1936, leading to Janes Island's abandonment and demise, Solomons Lump keeper Henry Columbus "Lum B" Sterling walked across the ice to Smith Island after verifying the lamp would continue burning. His son Tom, fearing for his father's safety, climbed the Crisfield Ice Plant and upon seeing the offshore light shining, felt assured his father was safe. Young Sterling was unaware of his father's icy hike. (USCG.)

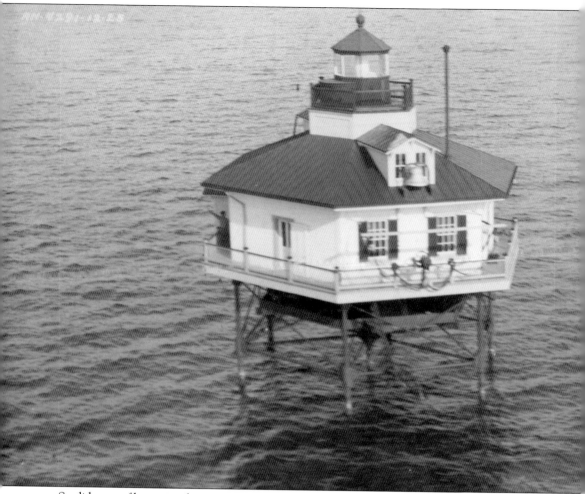

Sordid sagas of love triangles, rumrunners, and murder weren't just made for movies. The mysterious death of keeper Ullman Owens remains one of the Chesapeake's unsolved mysteries, despite the case being reopened later. Keeper Sterling of the Solomon's Lump Lighthouse noted that Holland Island light didn't flash its nightly warning and reported the failure to a passing mariner. The body of keeper Owens was discovered in disarray inside the lighthouse on March 15, 1931, amid signs of a struggle and blood, yet no wounds were found on his body. Rumors that an angry, jilted husband who'd been ditched in favor of Owens or illegal rumrunners (a witness reported seeing a darkened boat in the vicinity) may have been the culprits. Autopsies ruled Owens died of heart failure, thus natural causes. The state of the kitchen and blood found on the site were never explained, though some clues indicate Owens may have suffered from some sort of mental blackouts and taken his own life while not himself. (National Archives.)

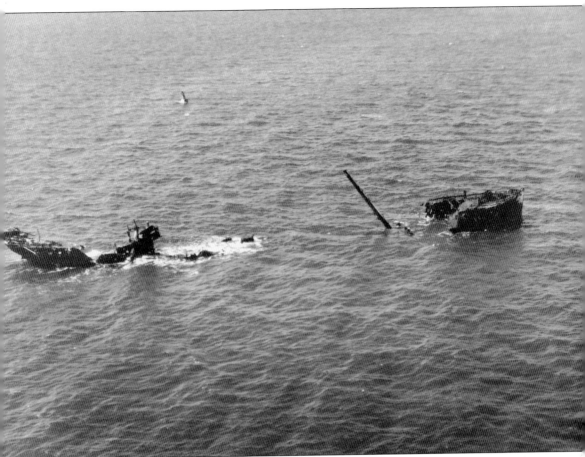

The mysterious tales surrounding Holland Island Bar light don't end with the unsolved death of keeper Ullman Owens. The rotted hull of the battleship *Hannibal* rested near the lighthouse and was the frequent subject of naval target practice. On February 19, 1957, four Coast Guardsmen were inside manning the light station when they suddenly found their station under attack as shells pierced the roof and careened through walls and iron supports. Navy bombers accidentally mistook the lighthouse for the grounded ship and fired practice flares through its superstructure and foundation. The men evacuated the station, and, thankfully, the practice rockets did not contain explosives. The shaken but dependable guardsmen returned the next day and repaired the lighthouse, which continued in service for a couple more years before being dismantled and replaced by an automated beacon. (USCG.)

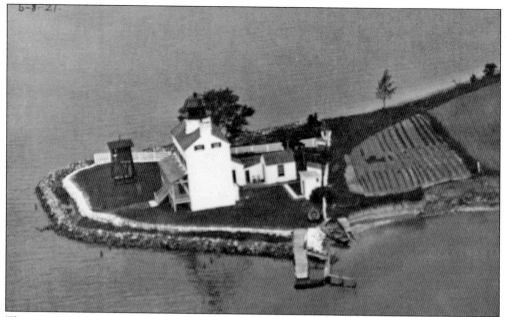

Threatened with explosives by Confederates during the Civil War, the Blakistone Island Light was spared because of the pregnant keeper's wife. Ironically, that's how the lighthouse ultimately left the island. Ownership of the island was turned over to the navy in 1919. A mysterious fire scorched the entire island in July 1956, gutting the building. Claiming it was unsafe, the navy used dynamite to demolish the structure. (USCG.)

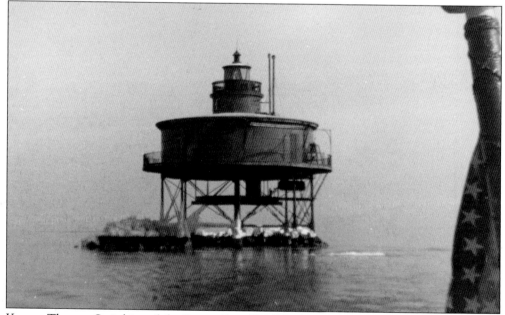

Keeper Thomas Steinhise of the Seven Foot Knoll Light Station in the Patapsco River was awarded the Congressional Medal of Honor for his daring and selfless rescue of five men from a sinking tug boat during a horrific nor'easter in 1933. Steinhise ventured into the waves with the lighthouse motorboat to retrieve the men from the water despite waves washing overboard and causing engine difficulties. (USCG.)

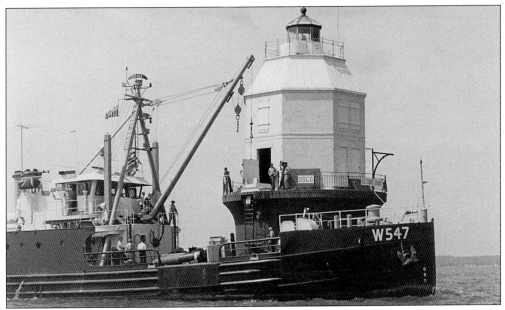

Lighthouses were occasionally used as test sites for new technology. Baltimore Harbor Light became the world's first atomic-powered light station when the Coast Guard buoy tender White Pine installed a 4,600-pound isotopic-powered generator known as the SNAP-7B in the lighthouse in 1964. The 60-watt generator, developed by the Atomic Energy Commission and built by the nuclear division of Martin Company, in Baltimore, was designed to supply a continuous flow of electricity for 10 years without requiring refueling. Testing had been initially performed on a navigational buoy beginning in 1961. The generator only powered the light for two years before it was removed without further elaboration, and no further attempts to use nuclear power to light navigational aids evolved. (USCG.)

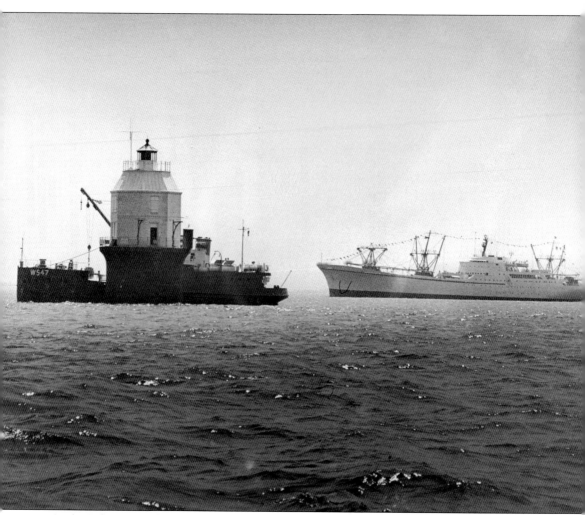

As the Baltimore Lighthouse became the first lighthouse in the world to be operated by an atomic generator, the first ship to pass the lighthouse was the nuclear-powered *Savannah*. This occurred while the buoy tender White Pine was installing the atomic generator. The crew of the tender waited on the gallery deck while the tender's boom lowered the generator to the crew who bolted it to a steel-plate base. The generator was housed in a specially constructed heavy steel hollow rectangular runway extending into the central column of the structure. The experimental nuclear-powered buoy was removed at the same time the generator was removed from the Baltimore Light. While the experiment was labeled successful initially, it appears to have failed to create a sustainable power source for navigational aids. Solar rechargeable battery banks power most active offshore aids. (USCG.)

Eight

ENEMIES OF THE LIGHTS

The answer to why so many lighthouses were lost is multifaceted, but several recurring themes evolve based on the different eras, architectural styles, and lighthouse administration.

Early lighthouses were often lost when the ground beneath them disappeared under the lapping bay waters. This reflects more on Stephen Pleasonton's choice of location, often guided more by price than practicality, than it does on the builders. Several of John Donahoo's early light towers stand to this day as testament to his skill and choice of materials.

Screwpiles, while cost-efficient and well-suited for placement away from shore, were no match for the heavy weight of compounded ice flowing down the Chesapeake. The ice didn't occur every winter, but when it did, it packed a lethal punch against the wood-frame cottages.

In the end, technology probably claimed more of the historic picturesque lighthouses than any other culprit.

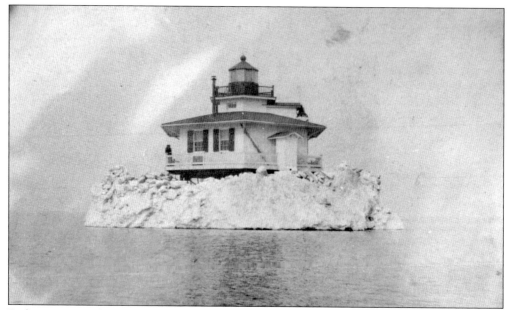

By far, enemy number one to exposed, offshore lighthouse stations, particularly screwpile foundations, was ice. Seemingly harmless by itself, flowing ice tended to build up around the light station foundations, as shown in these images of Love Point from the winter of 1902. Once packed inside, the pressure of additional ice could bend and warp the pilings and support braces. If ice persisted for some time, it could stack itself over 30 feet tall and shove superstructures completely off their foundations, as evidenced by lighthouses such as Janes Island, Sharps Island (the screwpile), Choptank River, and others. (National Archives.)

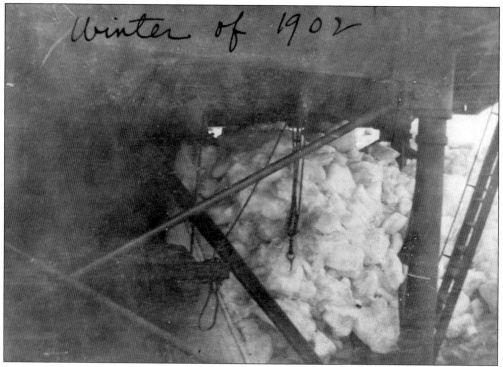

This damage at Holland Island was most likely because of ice rather than the unintentional bombing, as the date on these photographs is over 20 years prior to the incident. The USCG file caption reads, "Repairs to damaged casting as viewed from short distance from structure to show how straps blend in with casting, and do not stand out in a harmful manner. Degree of twist in bottom piles can be noted. Attention is called to center pile and casting, which was not damaged. 20 Ft. North. H.L.B. Aug 26/36." This appears to be the handiwork of ice, and the series of photographs demonstrate how the outer piles twisted while the center did not. Ice was so strong it upended large riprap stones at Thomas Point in 1918. (USCG/National Archives.)

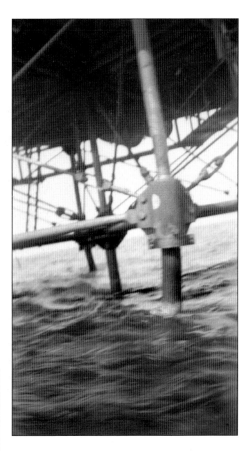

Thomas Point Lt. Sta., Md., March 20,1918. Looking approx. S; shows large riprap stone up ended by the ice.

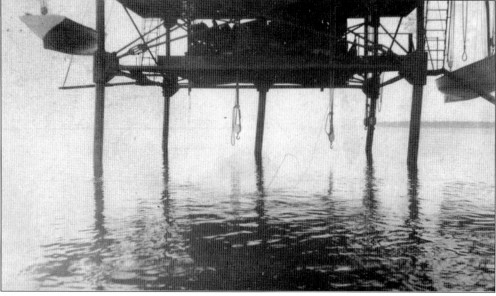

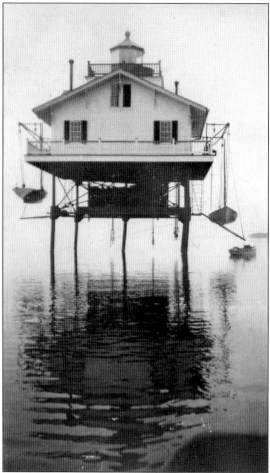

Cobb Point Bar's foundation pilings show evidence of skewing after the winter of 1917–1918. More braces must have been added across the bottom of the pilings, as they appear to be in place in later photographs. The center support piling exhibits a visible angle. Due to the loss of numerous screwpile and sleeve-pile superstructures more suited to calm waters not prone to moving ice, the Lighthouse Board switched to the caisson structures in the late 1800s to avoid loss in exposed locations. Despite the fact that many of the Chesapeake shoals are in positions necessitating lighthouses be located away from the safety of shore, more than twice as many screwpiles were constructed than caissons. (USCG.)

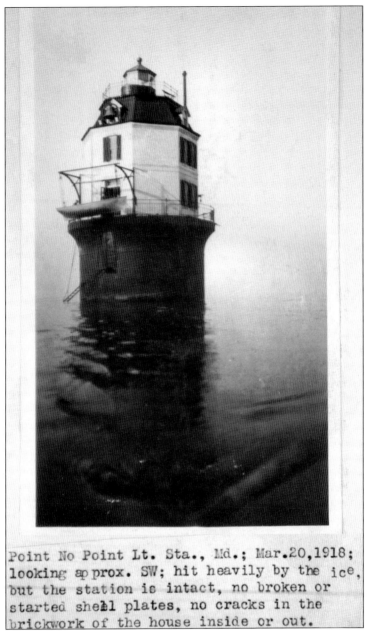

Point No Point Lt. Sta., Md.; Mar.20,1918;
looking approx. SW; hit heavily by the ice,
but the station is intact, no broken or
started shell plates, no cracks in the
brickwork of the house inside or out.

The decision to build a caisson at Point No Point turned out to be a wise one. A mere 13 years after the light station was lit, this March 1918 photograph was taken to show the station bore no damage from being "hit heavily by the ice, but the station is intact, no broken or started shell plates, no cracks in the brickwork of the house inside or out." Despite being automated in 1938, Point No Point was one of the last four lighthouses still manned by Coast Guard personnel in the Maryland waters of the Chesapeake Bay before it was converted to unmanned status in 1962. Keepers consisted of three men who worked 24 day shifts with 6 days off, meaning there were two keepers on the light station most of the time. They played cards, worked puzzles, and experimented with cooking to entertain themselves during the long lonely hours on the light station. (USCG.)

A vicious cycle repeated at Fort Carroll with vandals damaging equipment, and the Coast Guard repairing it, only to have it vandalized and damaged again. Eventually the Coast Guard determined the light was no longer necessary and discontinued it. Falling victim to vandals became a common occurrence among the automated, unmanned light stations. (USCG.)

Hand-in-hand with vandalism fell neglect. With no one at the light towers every day to attend to maintenance, neglect allowed the elements to turn small cracks into crevices, rainwater to penetrate and rot the wood that stood for decades, and paint to peel and flake away, exposing the wood underneath. (USCG.)

This image taken of the Fort Carroll fog bell housing, most likely during a Coast Guard inspection trip of the 1960s, shows the neglect as evidenced by the exposed wood floor protruding under the bell. The Coast Guard intended to demolish the structure for decades, but never did. Amazingly the tower is still standing. (USCG.)

Vandals threw this battery that operated the light to the ground, and another was found broken 100 feet away from the tower. The Coast Guard had just repaired similar vandalism at the light, but the unsecured ruins of the fortress proved too hard to resist for curious boaters. (USCG.)

Unmanned Fort Carroll is just one example of many where unauthorized access was easily attainable in offshore locales where no one watched. The corner beams of the light tower have graffiti etched into the wood, and the door stands weathered and ajar—too difficult to resist for the mischievous who don't mind the rodents. (USCG.)

Anyone who has completed a safe boating course knows that it is illegal to moor to or board an active aid to navigation. What about inactive aids? Prior to being moved to its new location in Baltimore's Inner Harbor, Seven Foot Knoll was a haven for graffiti, as evidenced in this photograph taken for the HABS survey in 1987. (Library of Congress.)

Many lighthouses waged a constant battle with erosion caused by the shifting and changing Chesapeake. Early lighthouses often lost the war, as retention walls and engineering of breakers had not advanced enough to prove effective. Aiding the bay was Stephen Pleasonton's miser mentality, and often inexpensive measures were ineffectively attempted to stem erosion. The complete loss of Cedar Point is one of the more regrettable tales in Maryland's lighthouse history. The sale of land to the Arundel Corporation and subsequent dredging furthered the bay's natural encroachment until the lighthouse stood on an island. Steps taken were not effective at stopping the lapping bay, which eventually washed over the island and left the lighthouse standing in a foot of water. The light was abandoned and eventually collapsed after some architectural features were salvaged for restoration and display. (Library of Congress.)

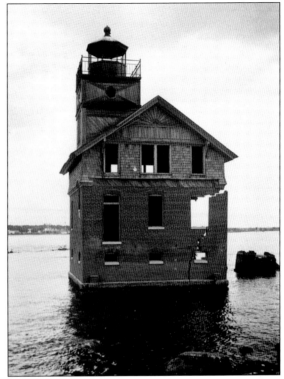

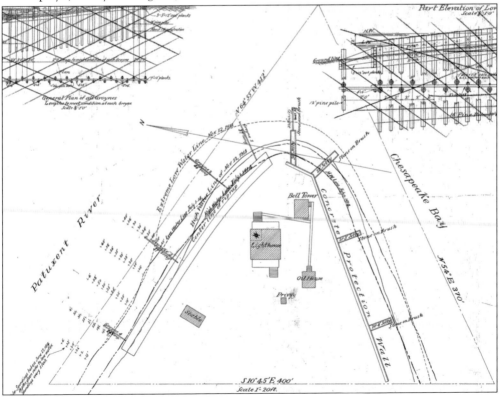

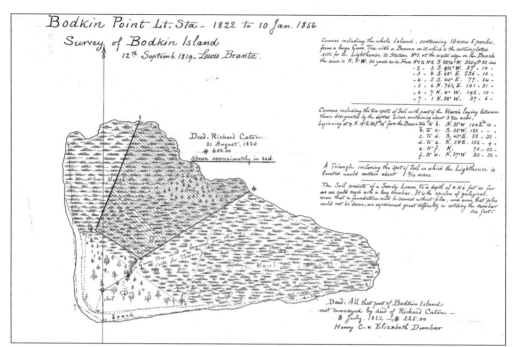

Much like Cedar Point found itself permanently rooted in a foot of water with no evidence of the peninsula it once stood on, other islands disappeared completely, such as Bodkin Island, on which the first Maryland lighthouse stood. Sharps Island also disappeared entirely, and other islands, once well populated, are merely bumps of their original form. (National Archives.)

As the beach began encroaching on Point Lookout, enough time had passed since the loss of Bodkin Island that technology had advanced enough to keep the creeping bay at bay from the light tower and buildings. Groins, or rock walls installed perpendicular to the beach, were installed to try to wash some of the sand back onto the beach and stem the erosion. (USCG.)

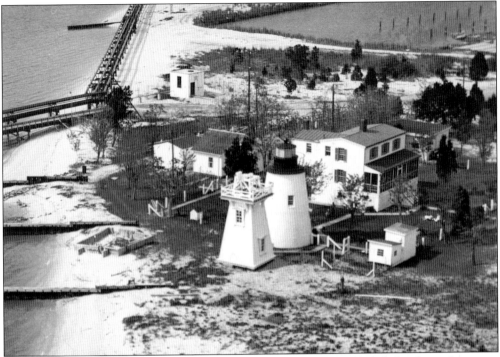

Early attempts at other light stations to install riprap and rock walls failed to keep the waters from the towers, particularly in instances where entire islands were washed over. Groins were also installed at Piney Point in 1850 to battle the erosion that caused a keeper to be fired for failing to stay on top of repairs. Piney Point eventually received a full retaining wall, and the lighthouse stands to this day. So efforts to stem erosion at that site, while difficult and over a long period of time, have worked so far. (USCG.)

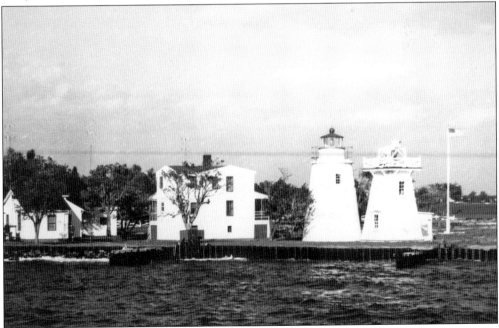

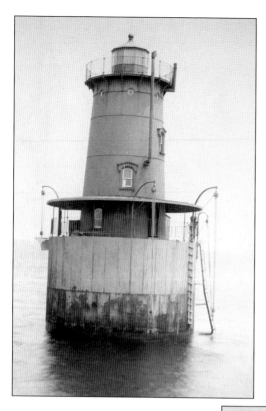

Scouring of the soft sand underneath caused two caissons to lean either shortly after construction in the case of Bloody Point below, or long after like Sharps Island above. Sharps Island tilted approximately 13 degrees from vertical after being battered by ice floes in January 1977, nearly a century after initial construction. A stability study conducted determined the structure would probably stand for some time, but might not withstand another battering. Bloody Point listed six degrees two years after being sunk after gales caused scouring underneath the caisson foundation. Attempts were made to correct the list by dredging sand from the high side and were only partially successful. (USCG.)

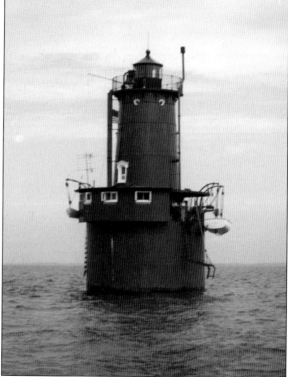

Technological advancements, such as the use of radio beacons in lieu of traditional fog bells like the one from Seven Foot Knoll, paved the way for automation and unattended beacons. As early as the 1930s, light stations began receiving equipment capable of running the lighting apparatus without human intervention and aids without fog signals became unmanned. Over time, the testing of radio and sensing equipment for emitting fog signals automatically during dense weather proved effective at eliminating the need for a person to wind the bell weights or turn the fog bell on. (Library of Congress/USCG.)

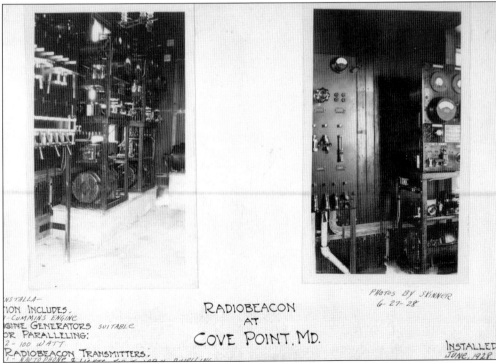

NSTALLA-
TION INCLUDES.
- CUMMINS ENGINE
GINE GENERATORS SUITABLE
OR PARALLELING:
2 - 100 WATT
RADIOBEACON TRANSMITTERS:

RADIOBEACON
AT
COVE POINT. MD.

PHOTOS BY SKINNER
6-27-28

INSTALLED
JUNE, 1928

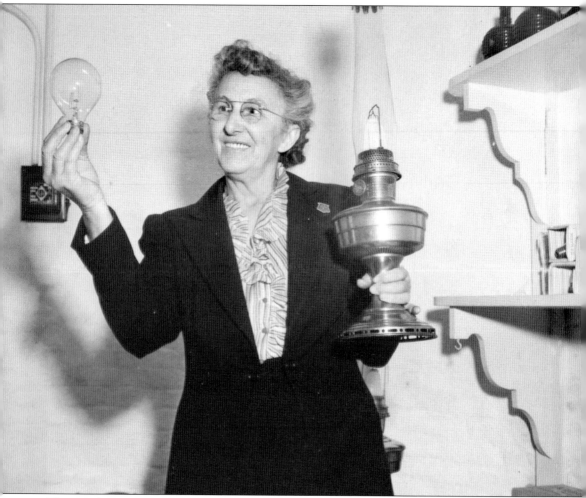

The wonderment in Fannie Mae Salter's expression over the new electric light bulb for use at the Turkey Point lighthouse reflects the excitement that often accompanies anything new. In one hand, she holds the electric light after her station received electricity in 1943, and in the other is the old incandescent oil vapor lamp she tended to for many years. Several trips a night up the steps were no longer required, unless she had to defrost the lantern panes during cold weather. Initial excitement over the ease of flipping a switch and no longer having to clean lamp chimneys probably would have faded had she lost her job over the new technology. Instead, her ward was automated and unmanned the year Salter retired, 1947. The fog bell tower eventually became a victim of erosion, and the light tower staircase was removed during automation to discourage vandals. (USCG.)

Not only did Salter's lighthouse receive electricity, removing the necessity of frequent staircase climbing, it also received an auxiliary backup system to provide power to the light should the main electricity fail. Such advancements in easing the arduous life of a keeper were highly touted and well received at the time. Perhaps no one foresaw what removing live personnel from the sites would mean to the structures themselves over time, as it left them without security or care. No longer requiring a keeper, the dwelling was removed in 1971 after vandalism, and only the light tower itself remains, though it was decommissioned in April 2000. (USCG.)

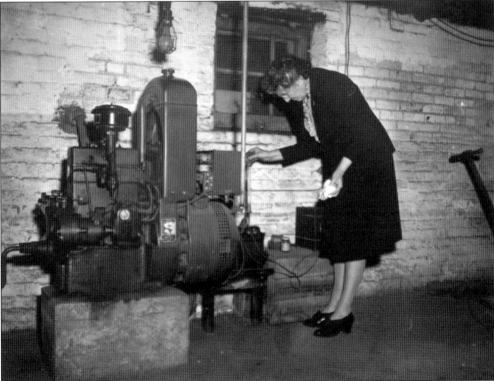

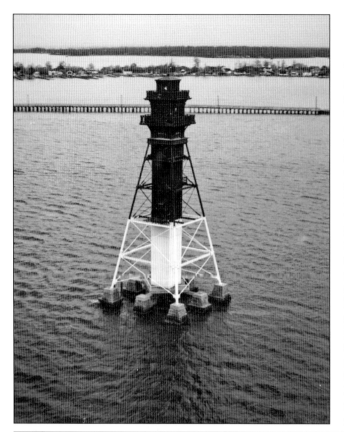

The Coast Guard published a request for bids on "demolition of the existing one and one-half story wood-frame dwelling and storage platform underneath the dwelling, and construction of a concrete deck, concrete block house and steel tower" at Holland Island Bar Light in 1959, two years after the friendly fire incident. After automation, the cost-effective reuse of existing foundations turned many former daymarks into nondescript lights, such as Lower Cedar Point (below), a typical example of what's become of many of the screwpiles formerly dotting the bay, and the Craighill Channel Lower Range Rear Light (above), shown after the dwelling was removed in the 1930s. (USCG.)

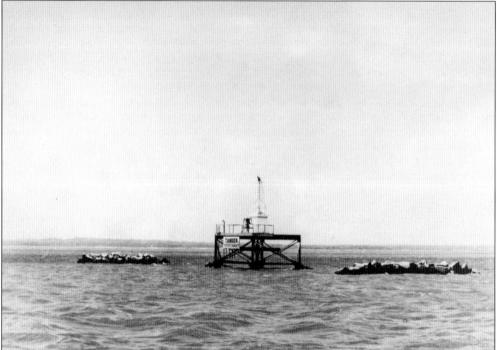

Nine

PRESERVATION AND VISITATION

Recognizing the ramifications of losing integral pieces of maritime history throughout the United States and realizing the Coast Guard did not possess the manpower or funds to stage a massive preservation and maintenance effort, the National Park Service (NPS) and General Services Administration (GSA) created the National Historic Lighthouse Preservation Act of 2000 (NHLPA). This act allows a process for the government to determine if a property, in this case lighthouse, is "excess" to their needs and transfer ownership to another party. A new era in lighthouse administration is under way, not only assuring longevity for generations, but also opening up access to lighthouses for enthusiasts.

Parties eligible to apply for ownership of a lighthouse at no cost are federal agencies, state and local governments, nonprofit corporations, educational agencies, and community development organizations. All applicants must agree to adhere to the Department of the Interior's standards of preservation and make the lighthouse available to the public.

If no eligible applicants are identified, then GSA puts the lighthouse up for auction. More lighthouses appear to be going in that direction, as there are limited nonprofits available with the resources to preserve and maintain lighthouses, and the ones who do acquire one generally have their hands full.

Prior to the NHLPA, ownership of lighthouses was transferred only when groups came forward at the time a lighthouse was scheduled for demolition. In such instances in Maryland, the lighthouses were moved to museum settings. Other preservation groups obtained historic leases on lighthouses in order to restore them and open them to the public, while the structure remained under the government's ownership. All organizations rely on volunteers and donations while offering unique opportunities for hands-on work in lighthouses to members.

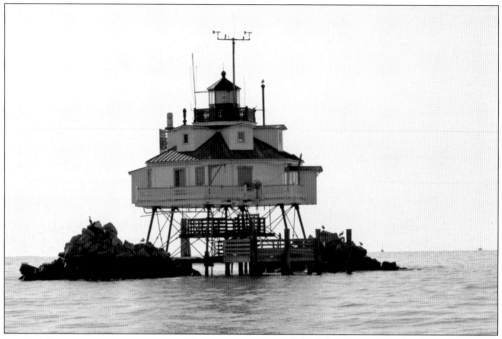

The Thomas Point Shoal Light Station was awarded under the NHLPA pilot program to the public/private partnership between the City of Annapolis; the Chesapeake Chapter of the U.S. Lighthouse Society, who leases and manages the preservation and operations of the structure; and the Annapolis Maritime Museum, housing the shore-based interpretive displays and launching point for public tours. The first feat the preservation group overcame with the installation of a new dock was accessibility to the offshore screwpile. It was customary to fly flags over light stations while they were manned, so the flagstaff at Thomas Point stood empty during the years of unmanned operation. Once preservation efforts began, the custom of raising flags up the staff resumed. Volunteers worked hard to restore the cottage, and public tours to the popular lighthouse began successfully for the first time during the summer of 2007. The Web site is www.thomaspointlighthouse.org.

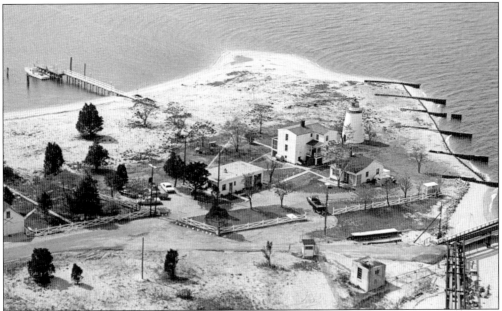

Decommissioned in 1964 and left abandoned, the Piney Point Lighthouse was deeded to St. Mary's County in 1980 by the federal government. Currently, in addition to the light tower and restored outbuildings, the property houses a museum store and river maritime exhibit. The light tower is open for climbing by visitors during normal hours of operation. More information is available at www.co.saint-marys.md.us/recreate/museums/ppl.asp. (USCG.)

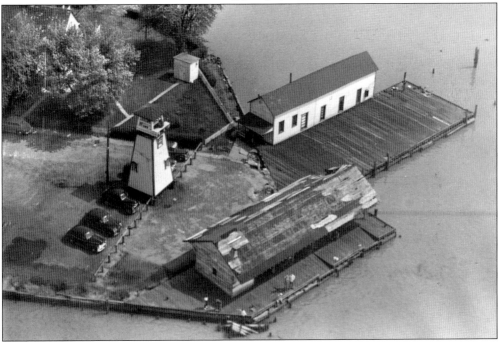

The Fort Washington light and bell tower, Light 80, is still an active aid to navigation located in the Fort Washington National Park, which offers picnicking and sightseeing. More information is available at www.nps.gov/fowa/historyculture/light80.htm. (USCG.)

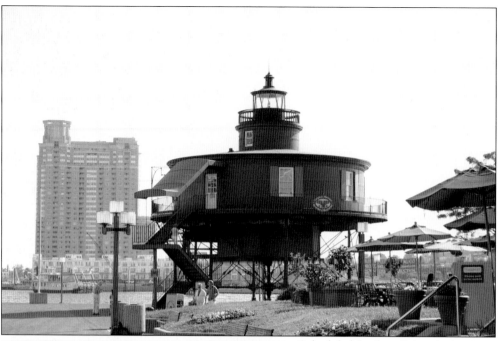

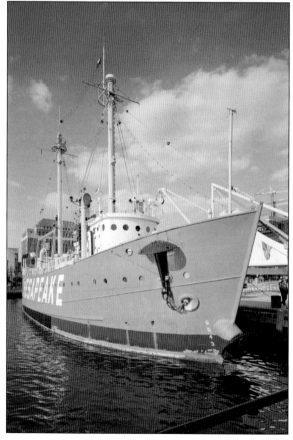

Scheduled for demolition during the automation era, the round, iron Seven Foot Knoll screwpile was donated to the City of Baltimore instead and moved with a crane from its offshore location to a pier on Baltimore's Inner Harbor. Restoration work proceeded over the next year with help from keeper Thomas Steinhise's family, and the lighthouse became the headquarters for the Living Classrooms Foundation. The lighthouse became part of the Baltimore Maritime Museum in 1997. Another Baltimore Maritime Museum exhibit in Inner Harbor is Lightship 166, also known as Lightship Chesapeake. Both sites can be toured during regular hours. More information can be found at www.baltomaritimemuseum.org. (Left, Library of Congress.)

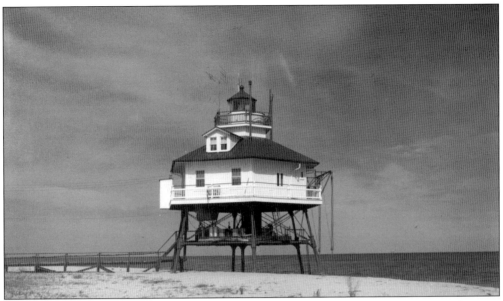

The Drum Point hexagonal screwpile was moved to the Calvert Marine Museum in Solomons, Maryland, in 1975, and restoration efforts began in earnest, as vandals had had their way with the light during its 13 years out of service. Beautifully restored and furnished, the museum offers guided tours that are scheduled seasonally. The grounds feature a large marine museum that includes a children's discovery room and outdoor exhibits. The Calvert Marine Musuem's Web site is www.calvertmarinemuseum.com. (USCG.)

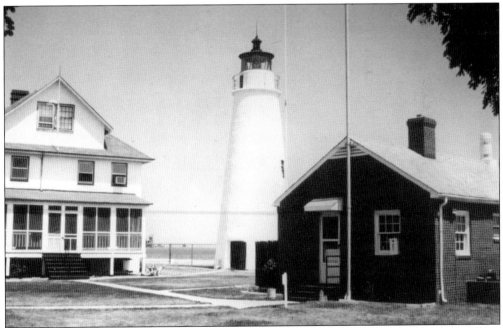

The Calvert Marine Museum also acquired the still-active Cove Point Lighthouse in 2000. The lantern room is off-limits, but visitors are encouraged to step inside the tower to peer up the spiral staircase. A museum guide is on-site during tour hours. Check with the museum for schedules. (USCG.)

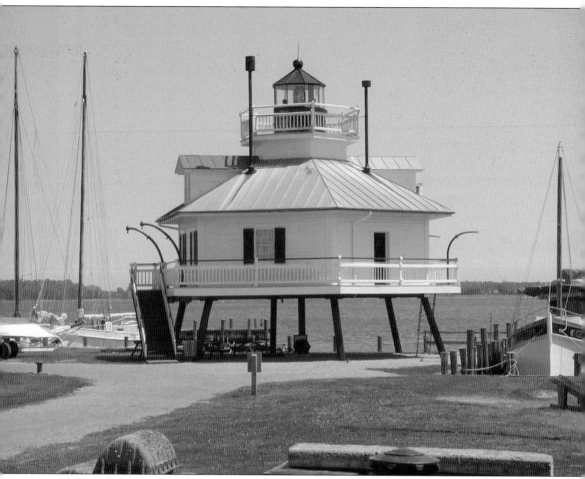

The wooden Hooper Strait screwpile cottage, originally built at Lazaretto Depot in 1879 to replace the ice-destroyed first cottage, now sits at the Chesapeake Bay Maritime Museum in St. Michael's, Maryland. While the recently decommissioned Drum Point lighthouse still stood at its original location, the Chesapeake Bay Maritime Museum was gifted the deactivated Hooper Strait lighthouse on the condition they foot the bill for moving it. In 1966, this had not yet been done to any of the Maryland lighthouses. The structure was cut in half and moved between 40 and 60 miles on a barge to St. Michael's harbor, where it was reassembled on a new foundation and restored. The lighthouse has been open to visitors since. The museum is open year-round, but hours vary by season. In addition to the lighthouse exhibit, the campus offers many other opportunities to explore Chesapeake Bay heritage, including a working boatyard. The Web site is www.cbmm.org.

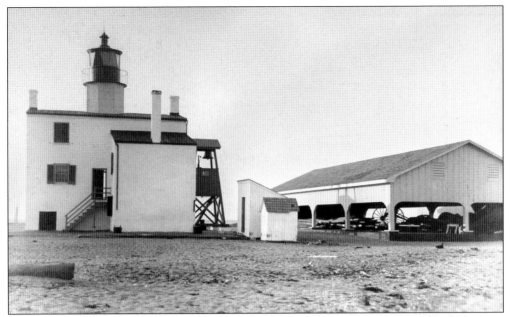

The U.S. Navy turned Point Lookout Light Station, sitting on the tip of Point Lookout State Park, over to Maryland State Parks in 2006, after many years of use. Point Lookout Lighthouse Preservation Society hosts open houses regularly and plans on expanding tours to the buoy and coal sheds once the U.S. Navy ends its tenancy. It currently offers daytime tours and nighttime paranormal investigations by reservation. See www.pllps.org for more information. (USCG.)

The original conical light tower built by John Donahoo in his hometown is open to the public in Havre de Grace from 1 to 5 p.m. on weekends in April through October. Managed by the Friends of the Concord Point Lighthouse, Inc., the keeper's dwelling was recently restored and is also open for touring, offering glimpses of the life of keeper John O'Neil. Information can be found at www.hdgtourism.com/do_museums.html. (USCG.)

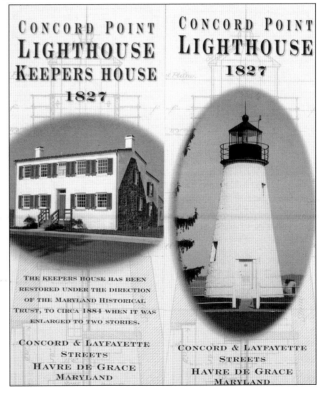

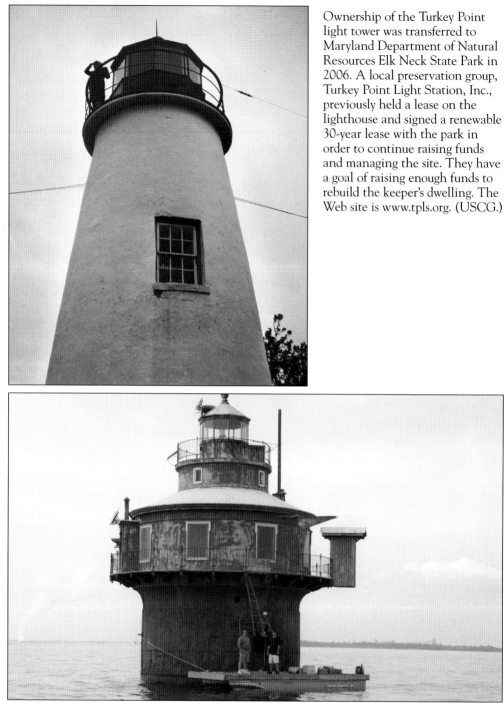

Ownership of the Turkey Point light tower was transferred to Maryland Department of Natural Resources Elk Neck State Park in 2006. A local preservation group, Turkey Point Light Station, Inc., previously held a lease on the lighthouse and signed a renewable 30-year lease with the park in order to continue raising funds and managing the site. They have a goal of raising enough funds to rebuild the keeper's dwelling. The Web site is www.tpls.org. (USCG.)

Historical Place Preservation, Inc., applied for and was awarded the Craighill Channel Lower Range Front Light Station through the NHLPA program. They are currently raising funds to rehabilitate the boat davits and lift, as well as to build a dock for safer access and staging of supplies. The lighthouse will open to the public once restoration is complete and safety is assured. The Web site is www.craighillrange.org.

No qualified nonprofits applied for the Baltimore Light after the Notice of Availability was issued. A private partnership purchased the offshore lighthouse sight unseen through the GSA auction and have been working to repair some water-damaged wooden support beams. But overall, the buyer lucked out. The light never was painted inside because of its short-lived era of manned operations, and one lighthouse restoration specialist was witnessed kissing the beautifully varnished wood, a rarity. The basement level features cisterns installed below the concrete floors and stylishly arched doorways. The center pole was painted with a wood grain and seamlessly blends in with the rest of the interior. The partnership has not yet disclosed plans for potentially opening the lighthouse to the public. The Web site is www.baltimorelight.org.

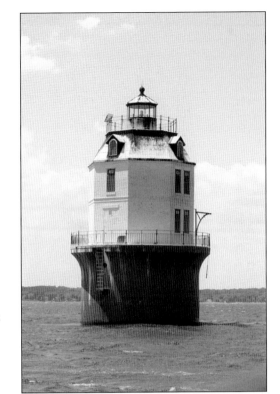

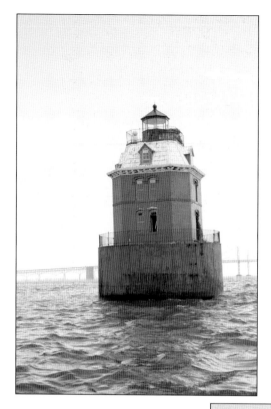

The Sandy Point Shoal Light Station had definitely seen better days by the time it hit the auction block in 2006 after no nonprofits applied. Broken windows and Victorian dental woodwork evidenced decades of neglect. Weeds sprouted through cracks in the concrete so much so, that passersby might think the lighthouse hosts a garden atop its deck. A private bidder purchased the light station, and future plans are unknown.

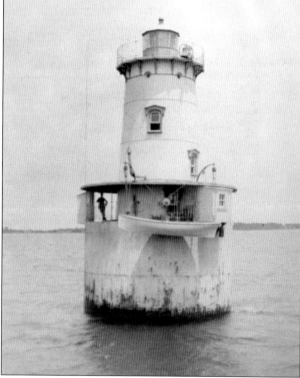

One can only hope the winning bidder for Bloody Point knew of the explosion that gutted the interior and cracked iron plates. Plus there's that permanent lean that required refitting the water tanks in order for them to function. Despite the lighthouse's unique characteristics, according to a December 2006 *Washington Times* article, the new owner from Nevada plans to properly restore the lighthouse. (USCG.)

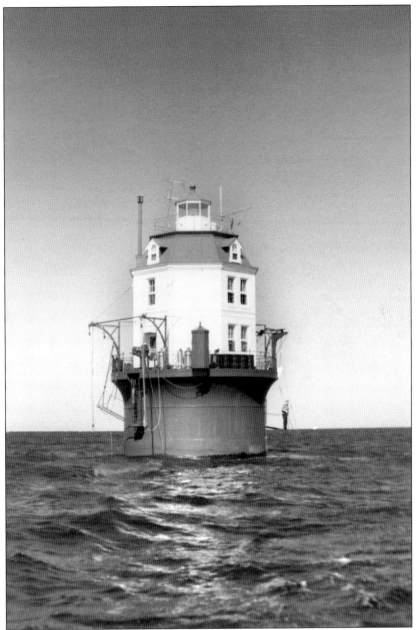

The most recent round of Notices of Availability were released, and Point No Point was listed with the GSA auctions after no qualifying organizations submitted applications. An inspection visit for potential bidders escorted by the Coast Guard took place in October 2007. The light station will eventually go to the highest private bidder. Point No Point appears to greatly resemble the Baltimore Harbor Light caisson right down to the cisterns hidden under the basement floor. Hooper Island Bar Light is currently in the application review process, meaning that at least one qualifying organization submitted an application. If one of those applicants is chosen to become steward of the Hooper Island light, it will also be opened to the public in some capacity. One of the major advantages of the NHLPA program, especially for the lighthouse-loving public, is that lighthouses that were previously completely unavailable are now more accessible. (USCG.)

ABOUT THE AUTHOR

ABOUT THE AUTHOR: Not as serious as appearing in this photograph while repairing gutters at Thomas Point, Cathy Taylor is an energetic lighthouse lover who founded the nonprofit organization Historical Place Preservation in order to preserve and promote lighthouse history. The organization applied for the Craighill Channel Lower Range Front Light Station during the national pilot of the NHLPA program. They were awarded stewardship of the offshore caisson at the end of 2005 after a grueling application process. Meeting the extraordinary challenges of an offshore light has kept Cathy busy but also provides her plenty of opportunities for her other passion—photography. Sales of this book will help with the organization's restoration efforts.

BIBLIOGRAPHY

Clifford, Mary Louise and Clifford, Candace J. *Women Who Kept The Lights, An Illustrated History of Female Lighthouse Keepers*. Alexandria, VA: Cypress Communications, 2000.

de Gast, Robert. *The Lighthouses of the Chesapeake*. Baltimore: Johns Hopkins UP, 1973.

DeWire, Eleanor and Paul Eric Johnson. *Lighthouses of the Mid-Atlantic Coast*. Stillwater, MN: Voyageur Press, Inc., 2002.

Henderson, Archibald. *Washington's Southern Tour, 1791*. Boston: Houghton Mifflin Company, 1923.

Holland, F. Ross. *Maryland Lighthouses of the Chesapeake Bay*. Crownsville, MD: The Maryalnd Historical Trust Press and The Friends of St. Clement's Island Museum, Inc., 1997.

Hornberger, Patrick and Linda Turbeyville. *Forgotten Beacons, The Lost Lighthouses of the Chesapeake Bay*. Trappe, MD: Eastwind Publishing, 2002.

Turbeyville, Linda. *Bay Beacons, Lighthouses of the Chesapeake Bay*. Annapolis, MD: Eastwind Publishing, 1995.

Vojtech, Pat. *Lighting the Bay, Tales of Chesapeake Lighthouses*. Centreville, MD: Tidewater Publishers, 1996.

INDEX

Discover Thousands of Local History Books Featuring Millions of Vintage Images

Arcadia Publishing, the leading local history publisher in the United States, is committed to making history accessible and meaningful through publishing books that celebrate and preserve the heritage of America's people and places.

Find more books like this at
www.arcadiapublishing.com

Search for your hometown history, your old stomping grounds, and even your favorite sports team.